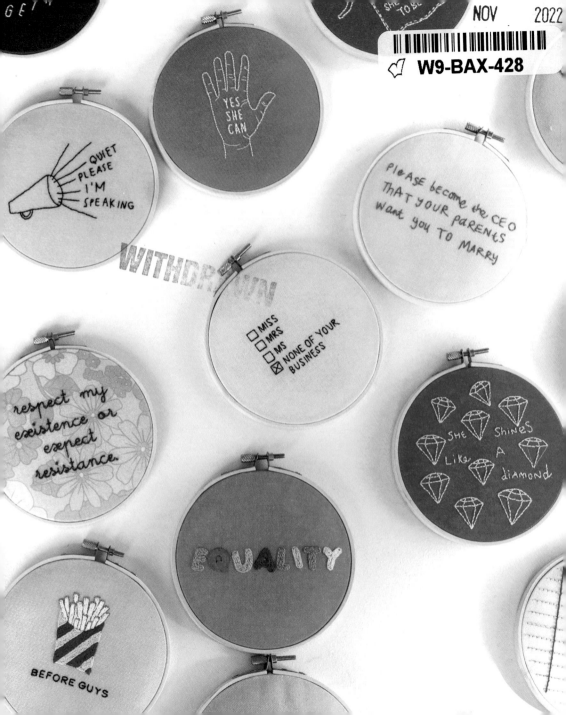

SISTERS
GONNA
STITCH

Mount Laurel Library
100 Walt Whitman Avenue
Mount Laurel, NJ 08054-9539
856-234-7319
www.mountlaurellibrary.org

Cotton Clara

SISTERS GONNA STITCH

A Feminist Embroidery Guide

HarperCollins*Publishers*

HarperCollins*Publishers*
1 London Bridge Street
London SE1 9GF

www.harpercollins.co.uk

HarperCollins*Publishers*
1st Floor, Watermarque Building,
Ringsend Road, Dublin 4, Ireland

First published by HarperCollins*Publishers* 2022

1 3 5 7 9 10 8 6 4 2

© Cotton Clara Limited 2022

Chloe Hardisty asserts the moral right to be identified
as the author of this work

A catalogue record of this book is available from the
British Library

ISBN 978-0-00-850936-1

Printed and bound in Latvia

CONTENTS

INTRODUCTION

Hello, I'm Chloe. I started Cotton Clara as a side-hustle back in 2014 and it has since turned into a full-time endeavour. My passion is making, and showing others how to be creative.

I have always loved embroidery. I discovered it in my teenage years, buying pocket-money cross-stitch kits from the craft shop, and I can still remember the feeling of satisfaction I'd get when I completed one, eager to go back and buy another!

I love it because it's so immediate. I have little patience and a short attention span – sadly, no one has ever succeeded in teaching me to knit or crochet. I just lose concentration! But with embroidery, the results can be seen straight away, there are no difficult techniques and you can pretty much teach yourself the basics.

The best thing of all is the positive impact embroidery can have on your mental health.

It takes time to practise and perfect your stitching style and master the steps, but you are very much in control once you have done so. There is no expensive equipment to buy – in fact, the most beautiful pieces can be made with equipment that costs pence (a rare thing these days). A tiny scrap of fabric and a length of thread can be transformed into something beautiful!

The best thing of all is the positive impact embroidery can have on your mental health. You have to put your phone down to do it! It takes two hands, and a little concentration. Just what our busy minds need in order to slow down. To work creatively, to lose ourselves in a project, to master a new skill – all of these things are so good for us, and can ultimately make us happier.

Historically, embroidery was seen as a 'domestic art'. This collection, however, is a celebration of the feminists who have come before us, and those who are still to come. My hope is that you will feel empowered and inspired while recreating these designs. When you have completed one, either display it proudly around your home, or gift it to a friend to share the love. I very much hope you enjoy the collection and the process!

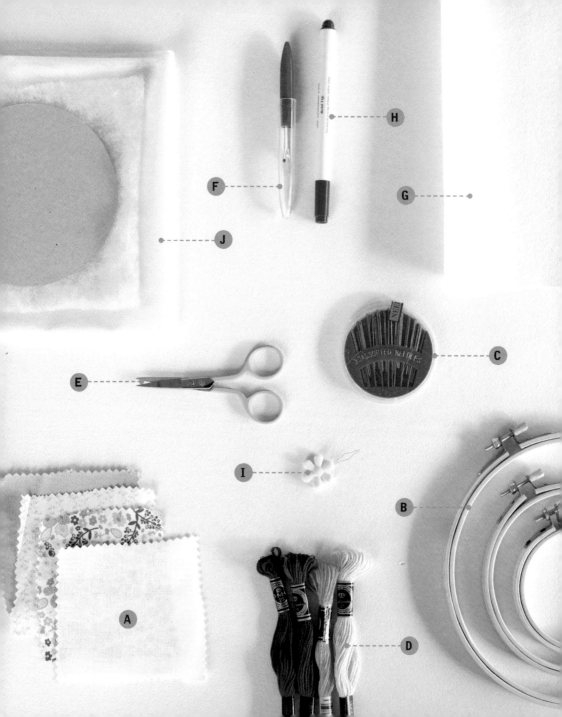

EQUIPMENT
YOU
WILL NEED

FABRIC

You can embroider onto anything you like if you have the right needle. I like to stick to medium-weight cottons, which give you a nice sturdy base. But you can stitch onto heavier fabrics, like denim and canvas, and lighter fabrics. With lighter fabrics you may want to use something called interfacing to back your fabric and give you a stronger base on which to sew.

Wool felt is also really lovely to stitch onto. Experiment with different fabrics, see what works and what you like; explore charity shops for amazing old fabrics – old tablecloths or an old shirt work really well.

If you're stitching onto patterned fabrics, a top tip is to stitch on the reverse of the fabric, so the pattern is slightly faded and your design is more likely to stand out.

EMBROIDERY HOOPS

I've used 13cm hoops for all of the designs in the book, but hoops come in all sizes, from small 9cm to bigger 20cm ones. If you're a beginner, it's probably easiest to start with a medium-sized hoop, 12–15cm. It's easier to get the fabric in nice and tight.

NEEDLES

You'll need an embroidery needle. These have a sharp end, so they help you place your stitches with precision and pierce the fabric. Confusingly, the larger the number the smaller the needle (and therefore the eye of the needle, making them more difficult to thread). I like using quite a large needle, a size 2 embroidery needle, but they range in size from 1–12.

THREADS

You'll need to use 'stranded cotton' embroidery thread. Widely available, this type of thread is split into six strands, hence its name. You can stitch with all six threads for a thick line of embroidery or use two or three for a thinner, more delicate stitch. We stitch most the designs in the book with two or three strands. Splitting your thread into the right number of strands is important as it will affect how your finished piece looks. You can get many different brands of thread, but we've given the colour references for DMC, the most popular range of thread.

SCISSORS

You'll need a sharp pair of scissors to snip your thread and cut fabric. Don't use them for cutting anything else and they'll stay nice and sharp for your embroidery work.

F

UNPICKER

This isn't essential, but it is a very useful tool. An unpicker will help you to remove stitches if you go wrong and want to start again.

G

TRANSFER PAPER

We use water-soluble transfer paper to trace the designs onto. This special embroidery paper then sticks to the fabric you are using, and you stitch over it. Once your design is complete, you can soak the fabric in water and the paper will disappear. We'll go through the different ways of transferring the designs in the next section. Using a light box is helpful or try holding your design up to a window.

H

TRANSFER PEN OR ROLLERBALL PEN

You can also use a light box for this technique, or on lighter fabric simply directly trace the pattern from the template. Using an air- or heat-erasable embroidery transfer pen means that the lines you draw can be removed, or will gradually disappear, depending on the type of pen you choose – leaving your embroidery looking perfect! If you're confident that you'll cover your design with your stitches, you can just use an ordinary fineliner pen. A rollerball style is best so that the ink doesn't bleed.

I

NEEDLE THREADER

Again, this is not an essential tool, but a needle threader can help if you struggle to thread your needle – and save hours of frustration!

WADDING AND CARDBOARD FOR BACKING THE HOOPS

Once you've finished, you'll most likely want to display your work in the hoop. To finish off the back, I always like to lay in some wadding to give the piece a nice plump or rounded look. I think the easiest way of backing hoops is to make a cardboard circle and push it in, keeping the wadding and the excess fabric secure. We'll go through this in further detail in the next section.

K

TRACING PAPER OR LIGHTWEIGHT PRINTER PAPER

You'll need a way of tracing the design from the book onto a separate piece of paper. You can use tracing paper, or some lighter-weight plain papers are see

through enough to use. Or you can photocopy the page you need from the book.

Experiment with different fabrics, see what works and what you like; explore charity shops for amazing old fabrics – old tablecloths or an old shirt work really well.

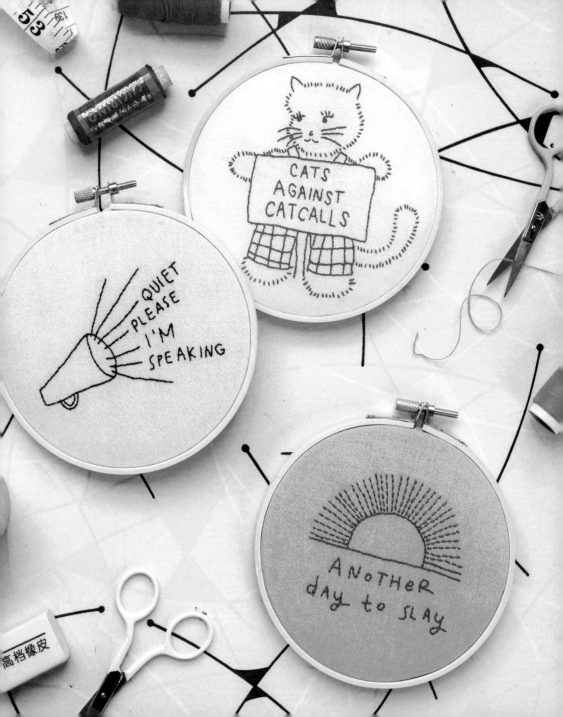

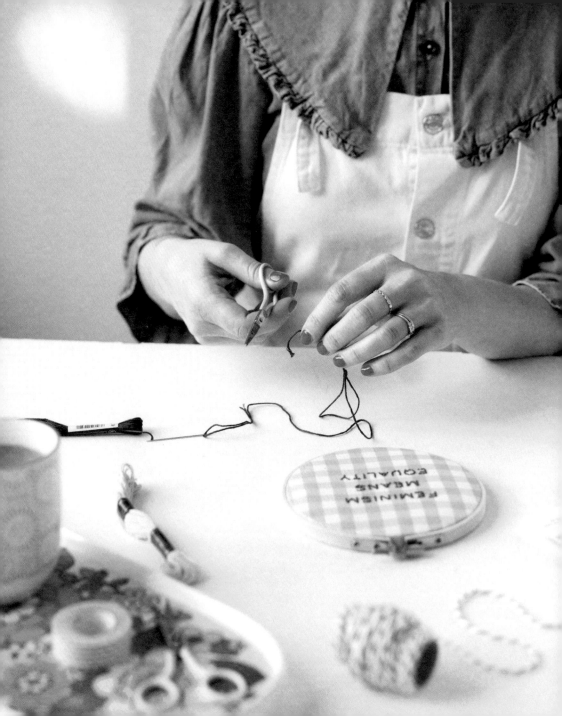

STITCHING

A **HOOP**

FROM

START TO FINISH

1

Iron your fabric if it's creased as any creases will be hard to get out after you have stitched it.

2

On a piece of cardboard (a cereal box or delivery carton) draw around the inside of the smaller hoops. Cut out the circle – you'll need this later to back the hoop.

I think it's easier to transfer the design you want to stitch before you put the fabric in the hoop, but some people prefer to do it the other way around. You can experiment to find your preference. I'll explain two different methods of transferring a design – tracing and using water-soluble embroidery paper.

Tracing

Choose the design you want to stitch and either photocopy it or trace it out onto white paper. This method is best for lighter fabrics; it won't work for darker or heavier fabrics.

Now lay your fabric over the template. You can use a light box or hold it up to a window to trace. With lighter fabrics the design will show through. Use an air- or heat-erasable embroidery pen to draw out your design – you'll then be able to get rid of any pen marks that are still visible once you've finished your embroidery. The most popular (air) pens disappear after twenty-four hours, or you can use a hairdryer to erase them with heat.

Water-soluble Embroidery Paper

Choose the design you want to stitch and trace it directly onto the paper. Use a light box for this, or tape your template and paper to a window.

The back of the embroidery paper is sticky, so you can place it onto your fabric. Do this after you've followed the next steps to put your fabric into the hoop.

Once your design is stuck in the position you want, you can start stitching through the fabric and the paper, following the design you have traced. When you're done, just remove the paper by soaking it in water and rubbing away the paper.

4

Now you have transferred your design, you are ready to place the fabric in the hoop. Unscrew the fastening on the hoop, then lay the smaller of the hoops on a flat surface. Place your fabric over the smaller hoop then put the larger one over the top, trapping the fabric in between the hoops. Now tighten the fastening again, and pull the fabric around the edges of the hoop so the surface is flat and even. You want to create a really taut base for stitching; it should be like a drum. Keep tightening the screw and pulling the fabric tight around the edge of the hoop until you are happy.

5

Now prepare your needle and thread. You'll need to know how many strands of thread the particular design you are stitching calls for. Once you know this, split your thread. To do this, cut a length of thread 40–50cm long. Grab the number of threads you want to stitch with and slowly separate them from the remaining threads. Tip: The slower you do this, the less likely you are to get in a tangle!

6

Next thread your needle; use a needle threader if you are struggling. Tie a knot at one end of the thread, leaving a 10–15cm tail coming out of your needle so the thread doesn't keep slipping out.

7

Start your stitching using the stitch guides in the next section. With all of the designs, the idea is to stitch over the pattern you have transferred. You are effectively drawing with thread. Use stitches between 2-5mm long depending on the length of the line in the design. Start anywhere on the hoop and just gradually cover over all of the lines you have drawn. Some of the designs are more detailed than others, so choose a simple one to start with if you are a beginner.

8

Once you have finished a length of thread, tie a knot in it at the back of your hoop as close as you can to the fabric, to keep the stiches tight.

9

When you've completed your design, trim any excess fabric from around the hoop. You want a 2–3cm border all the way around.

10

Cut a piece of wadding the size of the inside of your hoop and lay this in the back of the hoop. Now fold in the excess fabric and push the cardboard circle you cut earlier into the back of the hoop. It should be the right size to hold the wadding and excess fabric in place and will give a tidy finish to the back.

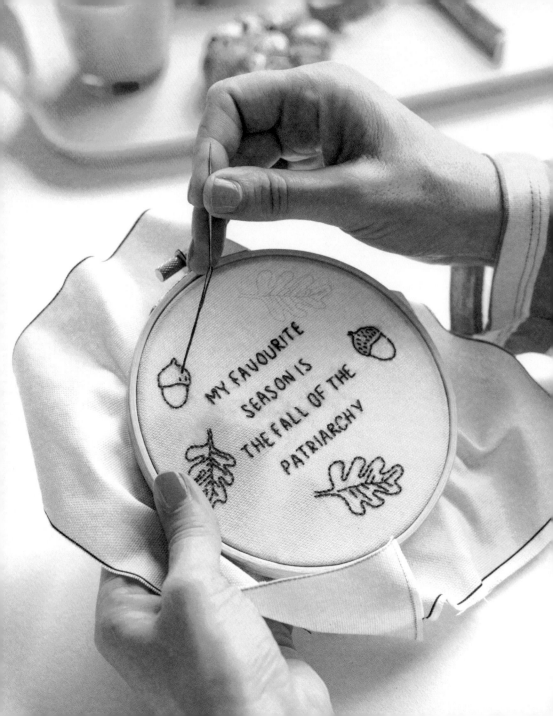

THE
STITCHES
WE USE

I've kept it really simple and I've only used three stitches in this book: backstitch; a variation on this, split backstitch; and satin stitch. But don't be fooled by the simplicity of these power stitches, it's possible to create quite complex designs with just these. At the start of your embroidery journey there's no need to spend time struggling with complicated stitches, just master these two foundation stitches and the extension stitch and you can build your stitching confidence and create myriad designs.

As with most things, you'll find that practice and repetition when it comes to embroidery is going to be your friend. Going over the same stitches and just building up those stitching hours will help you improve the most.

The joy is that once you have mastered these few stitches, completing a project will be so mindful as you find yourself automatically making your stitches and not having to think too much about the technical aspects.

BACKSTITCH

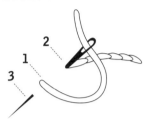

You can start stitching anywhere on your design. Come up with your needle from the bottom of the hoop, through the hole marked as no. 1 on the diagram. Pull your thread until the knot on the back stops it coming through.

Go down hole no. 2 and pull the thread through until it stops.

Come back up through hole no. 3, and then back down through no. 4.

You've done your first couple of back stitches. Just keep going using this technique to cover the pattern you've drawn.

You can start stitching anywhere on your design.

SPLIT BACKSTITCH

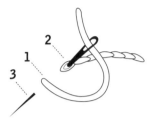

Split backstitch can be used to outline a shape, or for outlining text, or for filling in a shape. When filling in, start from the outside of each shape and neatly work your way in, building up lines of stitching to gradually fill the area. You can choose to fill in whatever pattern you like, up and down rows, or keep mirroring the outline of the shape working from the outside in.

Start with a single stitch, 3–4mm long. Bring the needle back up through the fabric at a point half the size of your stitch away, then go back down through the middle of your last stitch, splitting the thread. Be mindful of the tension in your stitches – don't pull them too tightly or you will see the fabric start to pucker.

When going around sharp corners, you may need to use a

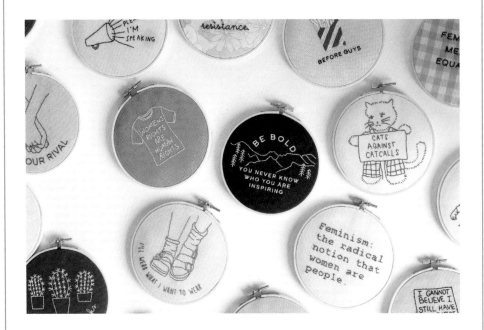

standard backstitch and go back down through the fabric at the end of your last stitch, rather than splitting it in the middle. This will allow you to create sharper angles.

SATIN STITCH

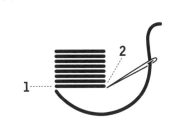

Satin stitch is used to fill areas and creates a smooth 'satin' type effect by having stitches lined up side by side.

Bring the needle up through the back of the fabric to the point you need to start your stitch.

Take the needle down at the opposite point. Repeat with your next stitch, placing your stitches as close together as possible. You can always return and fill in gaps once you have filled an area with stitches.

EMBROIDERY

TIPS

If you're starting out and want to keep it simple – go for a light fabric that you're able to directly trace the design through.

A high contrast between thread colour and fabric colour makes stitches stand out.

Don't double up the thread. Lots of us are taught to do this then tie a knot using both strands of thread,

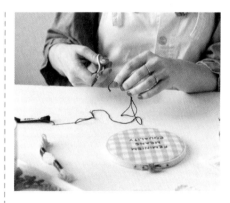

but you'll find it trickier to unpick your stitches if you go wrong if you use this method. Stick to tying a knot on one end of the thread and leaving the thread loose.

Play around with colour combinations until you find something that really pops, if in doubt go for black or red as they stand out on most fabrics.

One shape at a time. Don't jump from area to area with your thread.

Stitch one area of the design at a time, then tie a knot at the back and start a new length of thread.

Jumping from section to section with your thread will cause the thread to show through on your finished piece and look messy.

There are lots of different methods for finishing off the back of your embroidery hoop, you can use glue or stitches to add a fabric backing – but I think the cardboard disc method is the best!

Display by attaching and hanging with a ribbon. Or set on a gallery wall or just prop up on a shelf. Little hoops make great present toppers, too, or how about festive tree decorations?

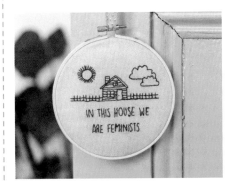

IN THIS HOUSE WE ARE FEMINISTS

THE

EMBROIDERIES

CATS AGAINST CATCALLS

DIFFICULTY RATING

THREAD COLOUR REF

666

THREAD INSTRUCTIONS

2 x strands back stitch

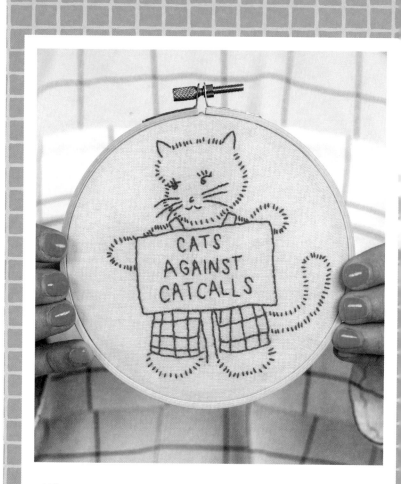

We can always rely on our feline friends to be on our side (providing we have the appropriate treats to hand, of course)!

Celebrate them in all their purrfect glory and gift this to your cat-loving confidante.

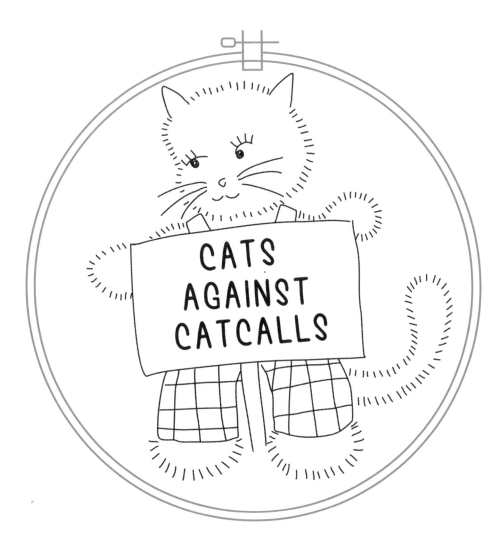

ANOTHER DAY TO SLAY

DIFFICULTY RATING

THREAD COLOUR REF
798

THREAD INSTRUCTIONS
*2 x strands
back stitch*

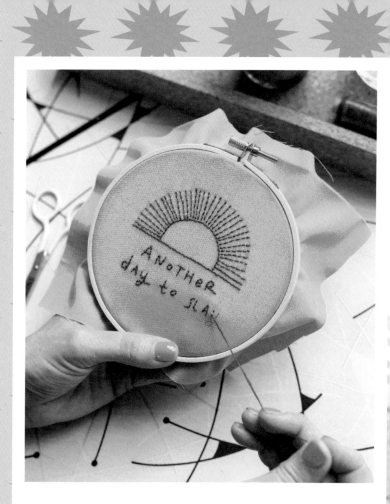

You have so much to give. Be the sunshine even when everything seems grey. The world needs you to wake up and SLAY!

Pop this one next to your bedroom mirror for a dose of daily inspiration.

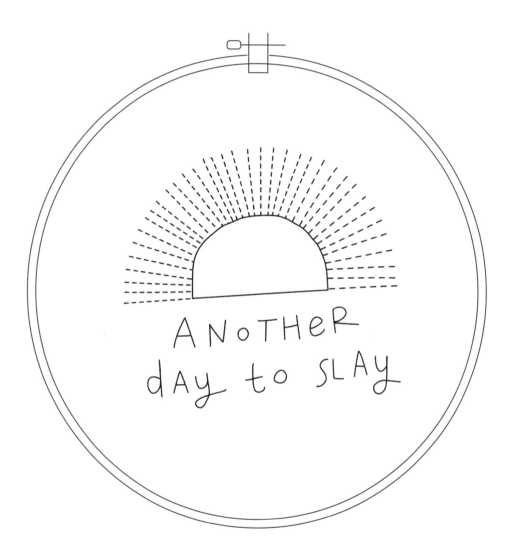

ANOTHER
DAY to SLAY

QUIET PLEASE I'M SPEAKING

DIFFICULTY RATING

THREAD COLOUR REF

310

THREAD INSTRUCTIONS

2 x strands
back stitch

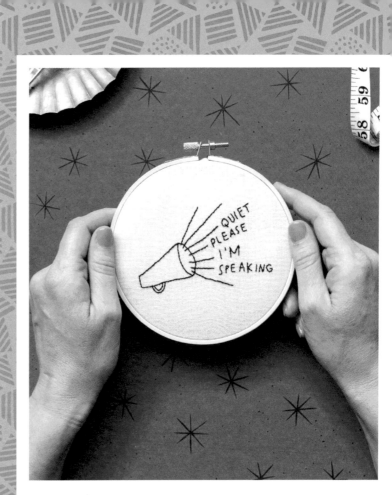

This is a reminder to never doubt that YOU DESERVE TO BE HEARD. Don't let anybody talk over you or make you silent. And don't even think about stopping speaking until your point is made.

Carry a megaphone at all times, just in case.

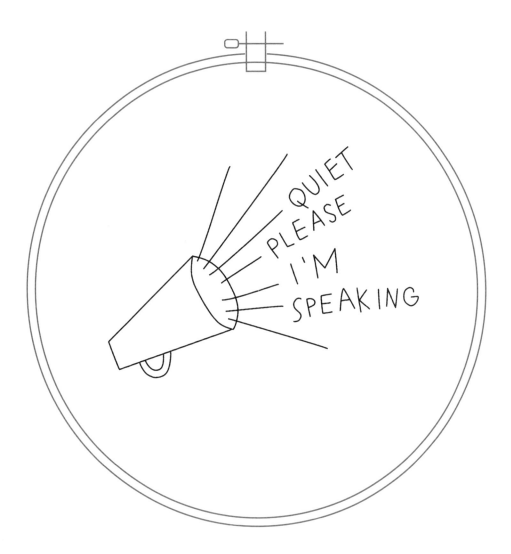

HEAR ME ROAR

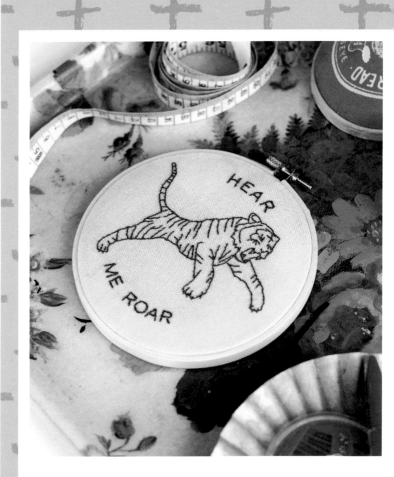

Connect to your inner spirit animal and release any stress with a thunderous roar!

Your neighbours might think that you've lost it, but your mind will be clear to really focus your efforts on recreating this lovely tiger.

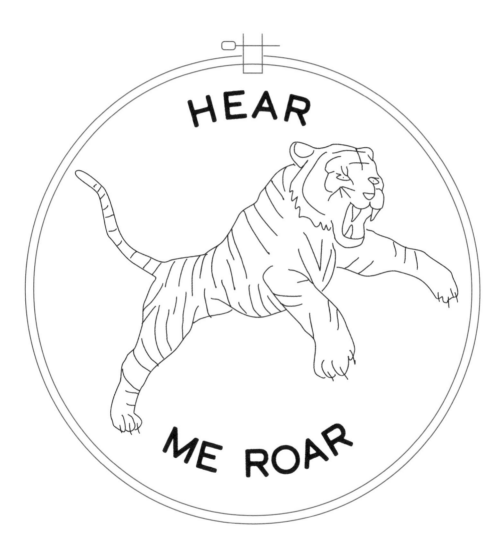

I DON'T CARE WHAT YOU THINK ABOUT ME

DIFFICULTY RATING

THREAD COLOUR REF

3685

THREAD INSTRUCTIONS
*2 x strands
back stitch*

I don't care what you think about me. I don't think about you at all.

Coco Chanel

This is easier said than done, Coco. Take a leaf out of Chanel's book and try to let go of any need for approval. Once you have a taste of that freedom, nothing can hold you back.

I don't care what you think about me I don't think about you at all.

Coco Chanel

HELP EACH OTHER GROW

THREAD COLOUR REF

700

THREAD INSTRUCTIONS

*3 x strands
back stitch*

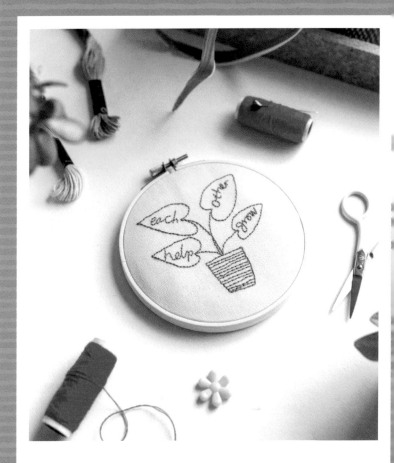

Just like you help your many, many houseplants to grow, help your friends to grow and thrive and you'll get that love and energy back.

(But, seriously, stop buying houseplants. It's getting out of hand.)

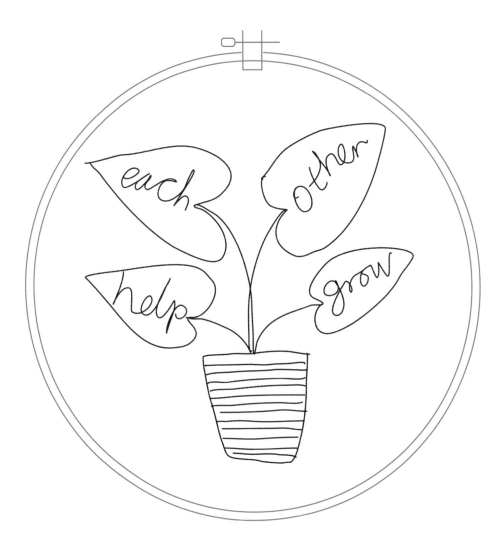

SELF-LOVE CLUB

DIFFICULTY RATING

THREAD COLOUR REF
826

THREAD INSTRUCTIONS
*2 x strands
back stitch*

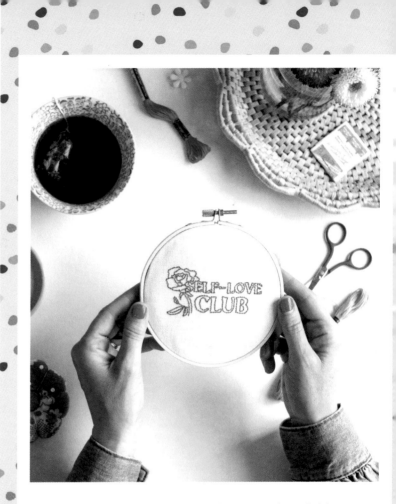

New members are always welcome to this club!
So, light a beautifully scented candle, put on your
favourite song and take your time on this one.

It feels good to take a breath and slow down
sometimes.

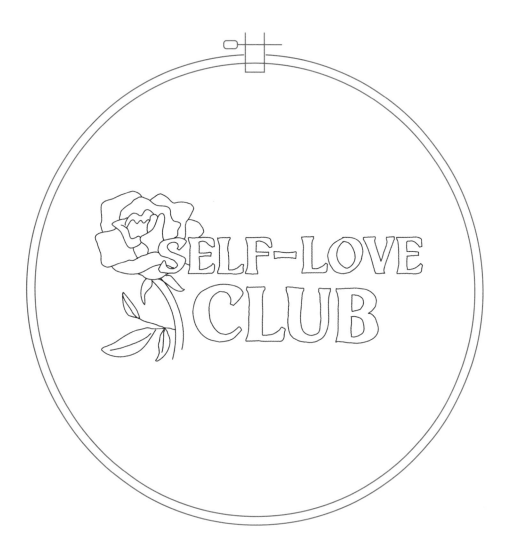

MY FAVOURITE SEASON

DIFFICULTY RATING

THREAD COLOUR REF

975

THREAD INSTRUCTIONS

*2 x strands
back stitch*

Don't get us wrong, we love the first flowers of spring, the warmth of summer, the cosiness of winter... but nothing quite beats this season!

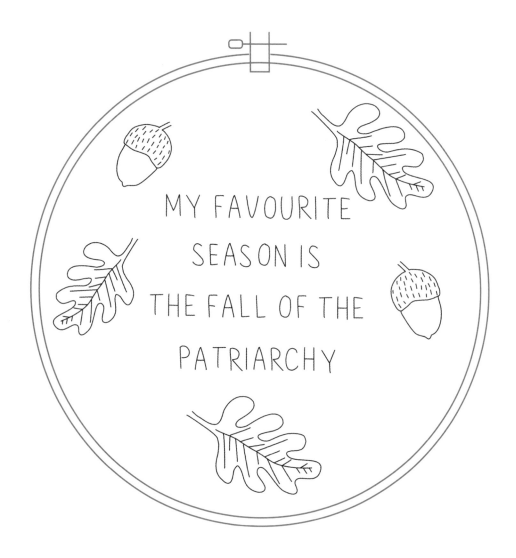

MY FAVOURITE
SEASON IS
THE FALL OF THE
PATRIARCHY

DIFFICULTY RATING

THREAD COLOUR REF

666

THREAD INSTRUCTIONS

*2 x strands
back stitch*

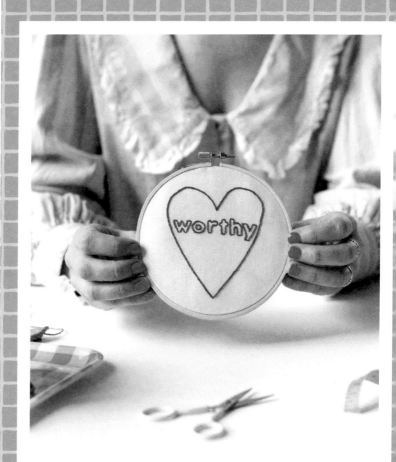

Yes, you are. Stitch this and put it somewhere you will see it every day, or give it to a friend who needs to know they are worthy of every fabulous thing that happens to them.

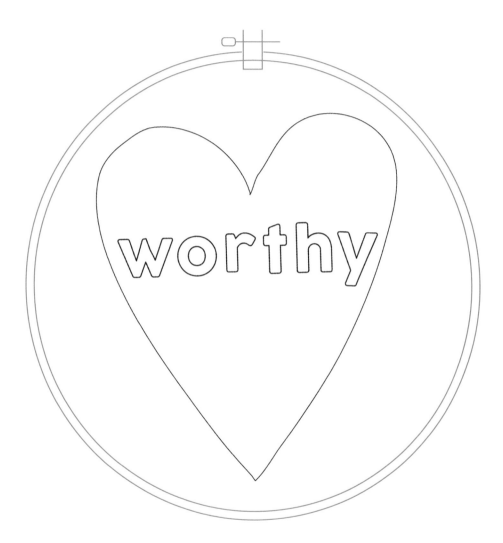

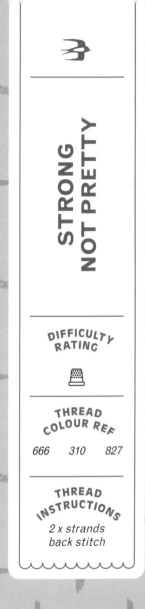

STRONG NOT PRETTY

DIFFICULTY RATING

THREAD COLOUR REF

666 310 827

THREAD INSTRUCTIONS

*2 x strands
back stitch*

This design is inspired by the poet Rupi Kaur. It is a reminder that we are so much more than our outward appearance. THIS is what we will be teaching the next generation of girls.

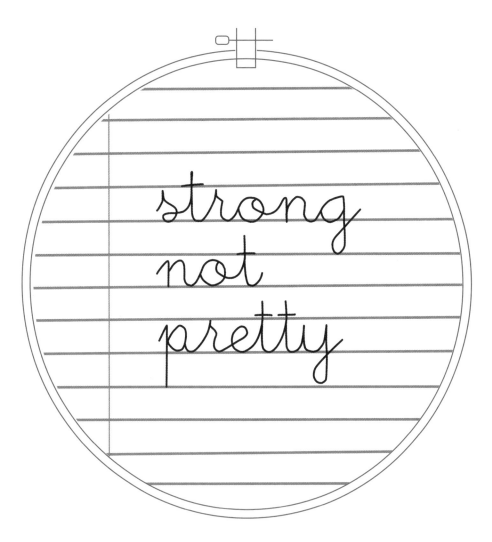

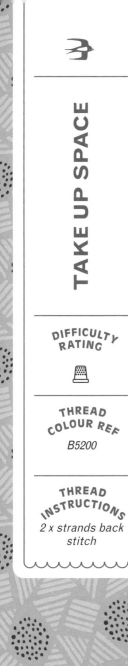

TAKE UP SPACE

DIFFICULTY RATING

THREAD COLOUR REF

B5200

THREAD INSTRUCTIONS

2 x strands back stitch

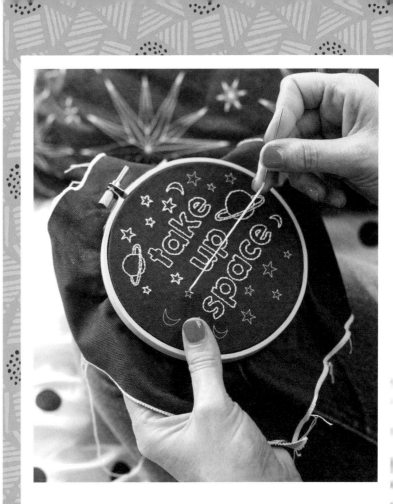

Yes you, make your presence felt and don't shrink back. No matter the circumstances, no matter the room, you have a seat at the table and the power to make an impact. And don't you forget it.

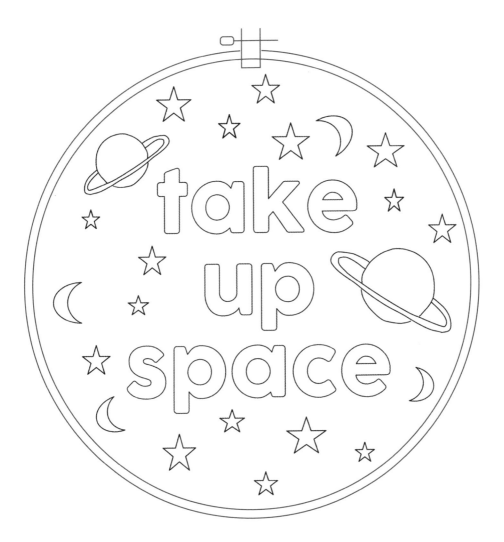

WOMEN WHO LEAD, READ

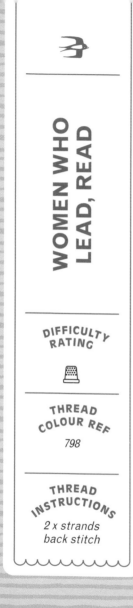

THREAD COLOUR REF

798

THREAD INSTRUCTIONS

2 x strands back stitch

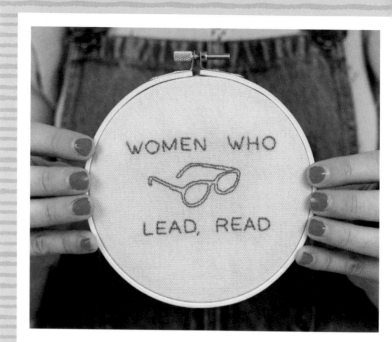

Fill your bookshelves with inspiring stories of women who took action and become the leader you want to be. We recommend kicking off your feminist library with these fantastic reads:

We Should All Be Feminists by Chimamanda Ngozi Adichie

Invisible Women by Caroline Criado Perez

Becoming by Michelle Obama

A Room of One's Own by Virginia Woolf

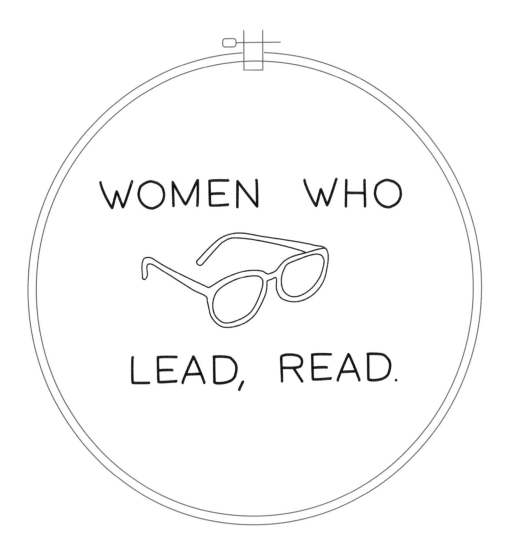

FRIES BEFORE GUYS

DIFFICULTY RATING

THREAD COLOUR REF

666, 310, ECRU, 445, 729

THREAD INSTRUCTIONS

Text and fries: 2 x strands back stitch; image: 3 x strands split back stitch

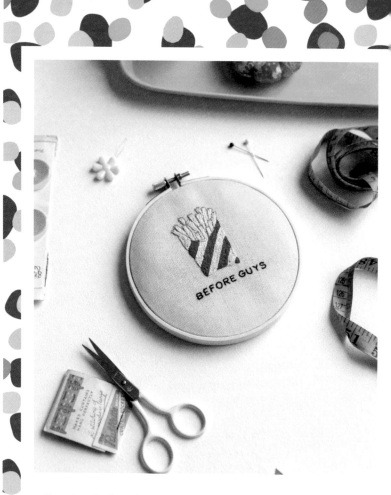

Ovaries before brovaries! Sisters before misters! Whatever you want to call it, be sure to get your priorities straight to really get optimal enjoyment out of those fries.

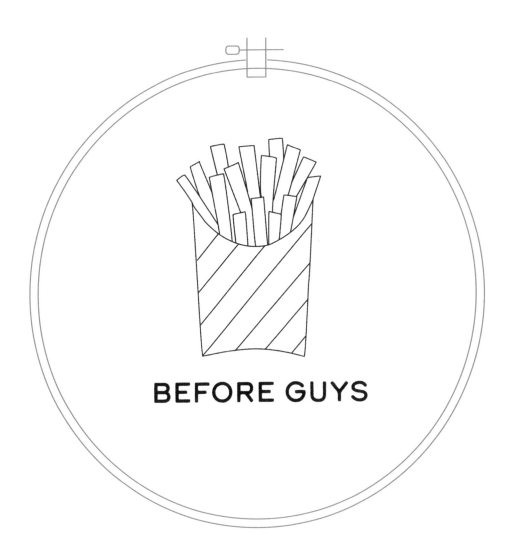

BEFORE GUYS

GOT ENOUGH PRICKS

DIFFICULTY RATING

THREAD COLOUR REF

B5200

THREAD INSTRUCTIONS

2 x strands
back stitch

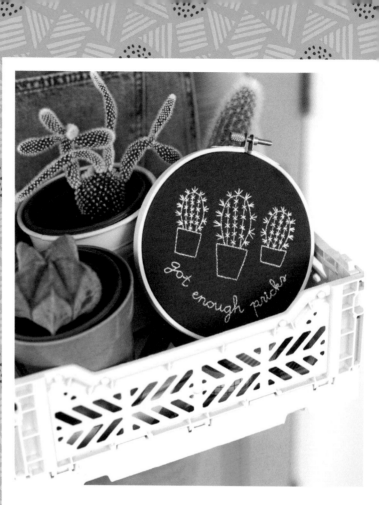

Yep, don't need any more pricks in our lives thank you!

Gift this one to your best plant-lady pal.

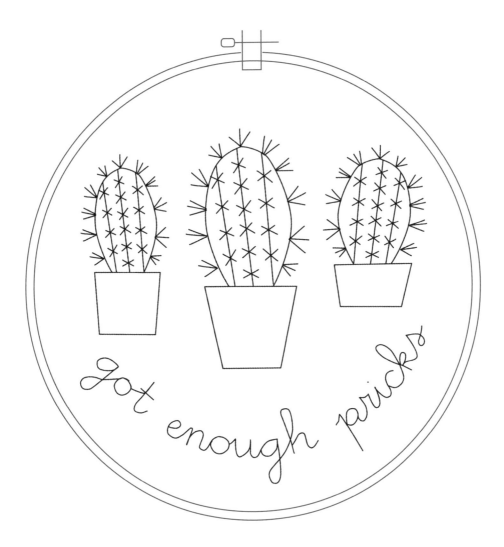

DIFFICULTY RATING

THREAD COLOUR REF

892

THREAD INSTRUCTIONS

Text: 2 x strands back stitch; image 1 x strand back stitch

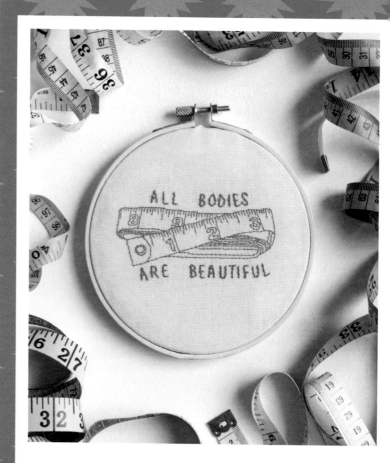

Finally, the world is waking up to the fact that every size, every shape, is perfect in its own way. Just like souls, bodies grow and change constantly, so try to enjoy the ride.

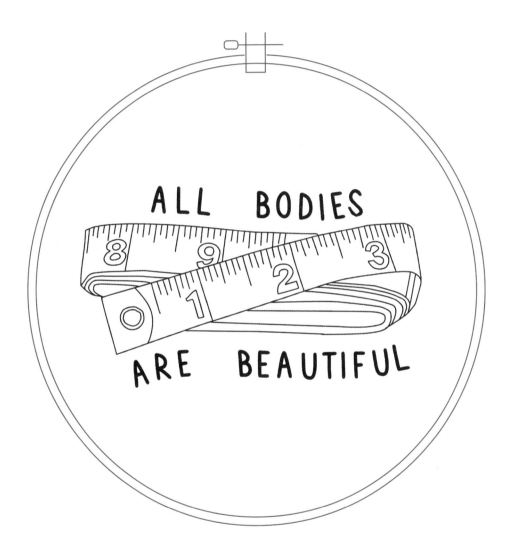

DESTROY THE PATRIARCHY NOT THE PLANET

DIFFICULTY RATING

THREAD COLOUR REF
699

THREAD INSTRUCTIONS
2 x strands back stitch

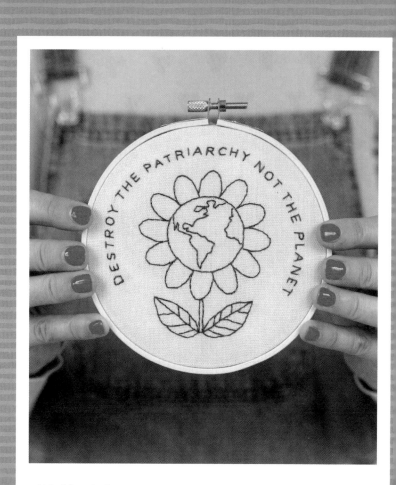

We bloody love equality and we bloody love the planet. Keep planting those feminist seeds and let the good times grow!

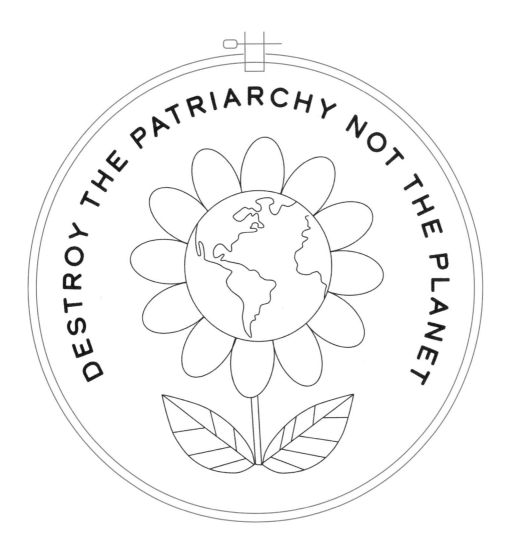

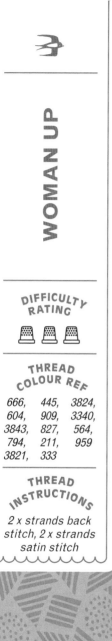

WOMAN UP

DIFFICULTY RATING

THREAD COLOUR REF

666, 445, 3824,
604, 909, 3340,
3843, 827, 564,
794, 211, 959
3821, 333

THREAD INSTRUCTIONS

2 x strands back stitch, 2 x strands satin stitch

Woman Up (verb): to deal with a situation rationally, calmly, maturely and without ego.

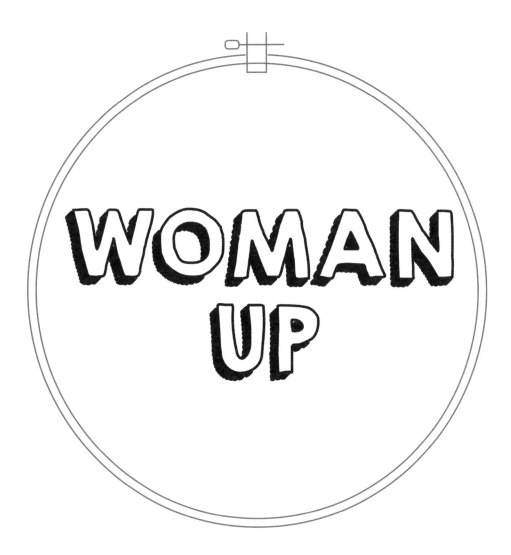

FEMINIST

DIFFICULTY RATING

THREAD COLOUR REF

210

THREAD INSTRUCTIONS

*3 x strands
split back stitch*

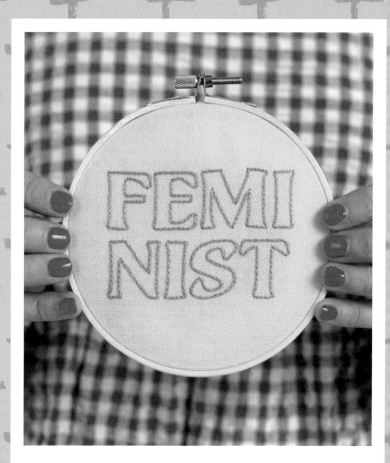

Take comfort in the fact that each and every feminist movement brings a new wave of supporters who are working towards a better world.

Gift this to somebody who is just beginning their feminist journey.

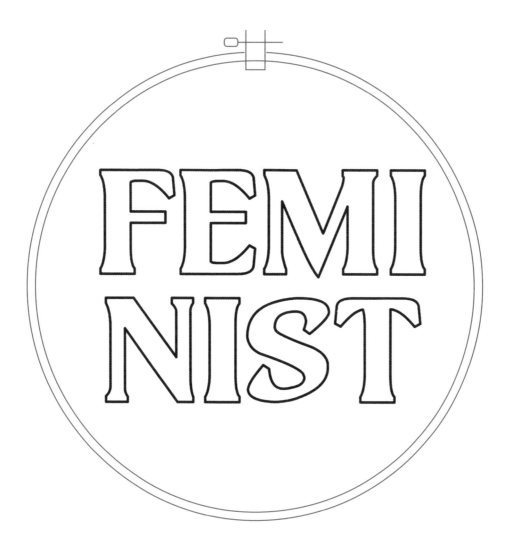

DIFFICULTY RATING

THREAD COLOUR REF

3837

THREAD INSTRUCTIONS

2 x strands
back stitch

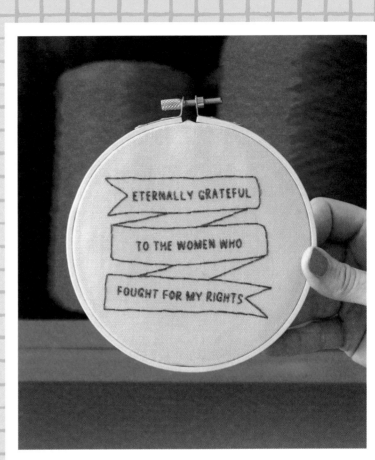

May we never forget how hard the battle was for our vote and our rights, and those women who suffered for us.

We salute you.

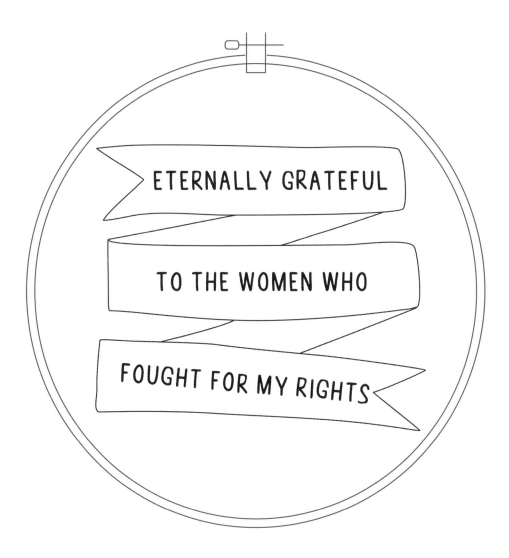

YOU GO GIRL!

DIFFICULTY RATING

THREAD COLOUR REF
666

THREAD INSTRUCTIONS
*2 x strands
back stitch*

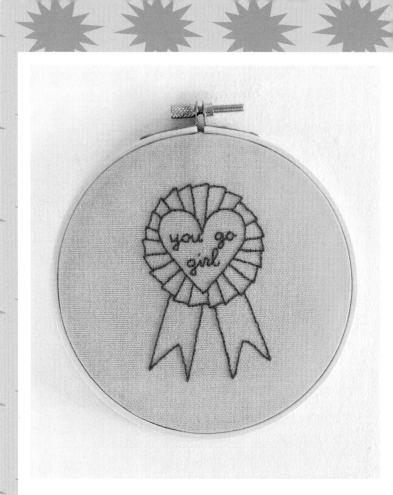

All those who have overcome the obstacles, persevered, stayed the course – you deserve a badge of honour.

Wear this one with pride.

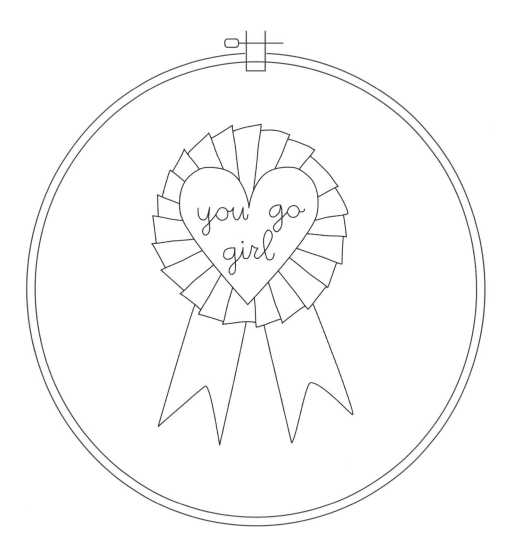

PLANT YOUR OWN FLOWERS

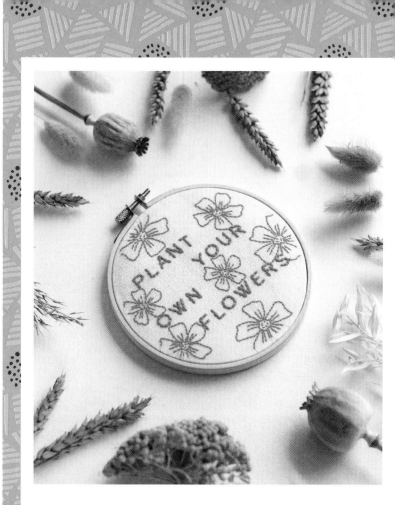

If there's anything you want in this world, go out and get it! Life's too short to sit around waiting for things to be presented to you.

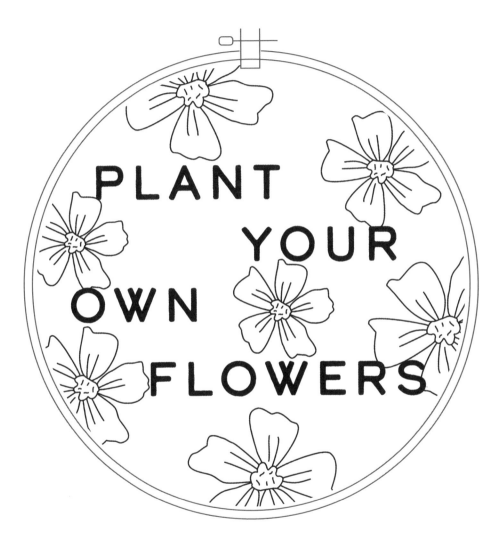

RESPECT

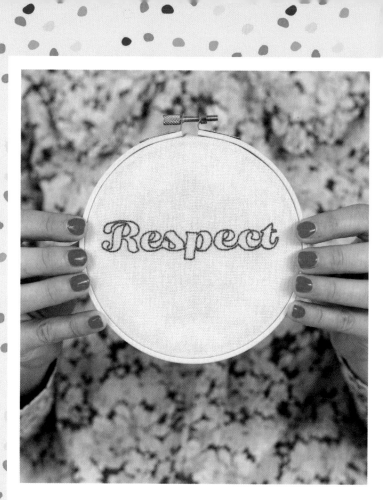

DIFFICULTY RATING

THREAD COLOUR REF
301

THREAD INSTRUCTIONS
*2 x strands
back stitch*

Aretha sure did sing it best.

We suggest popping on the song while you stitch this pattern. In our experience, the finished product comes out better that way ...

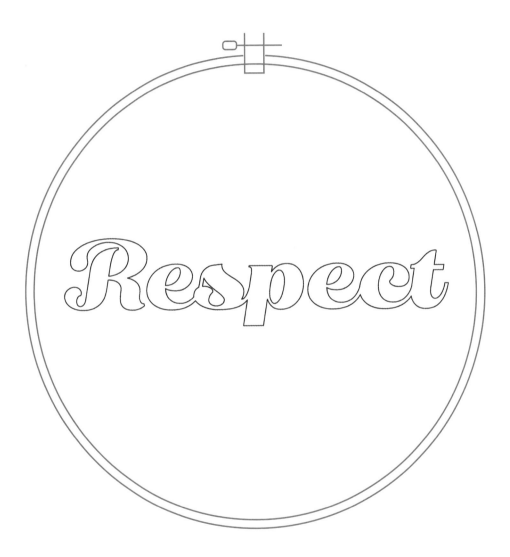

MISS, MRS, MS, NONE OF YOUR BUSINESS

DIFFICULTY RATING

THREAD COLOUR REF
310

THREAD INSTRUCTIONS
2 x strands
back stitch

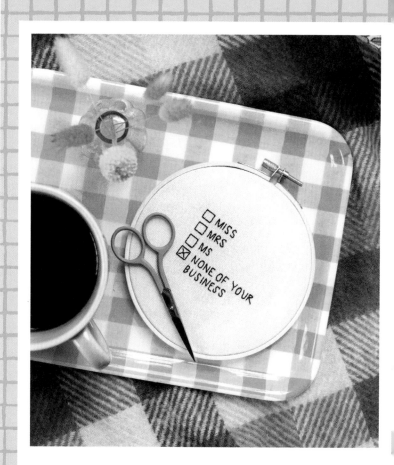

Does anyone else get sick of this?

One way to solve this problem is to get a doctorate. Now if that isn't motivation enough to stay in school, we don't know what is.

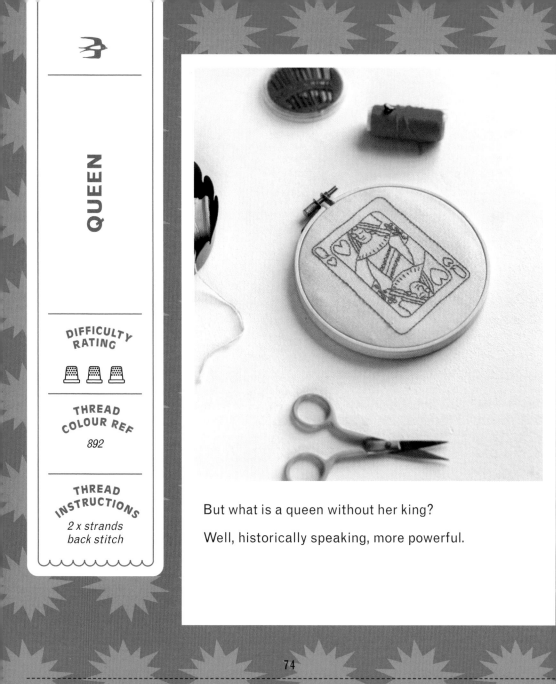

QUEEN

DIFFICULTY RATING

THREAD COLOUR REF

892

THREAD INSTRUCTIONS

*2 x strands
back stitch*

But what is a queen without her king?

Well, historically speaking, more powerful.

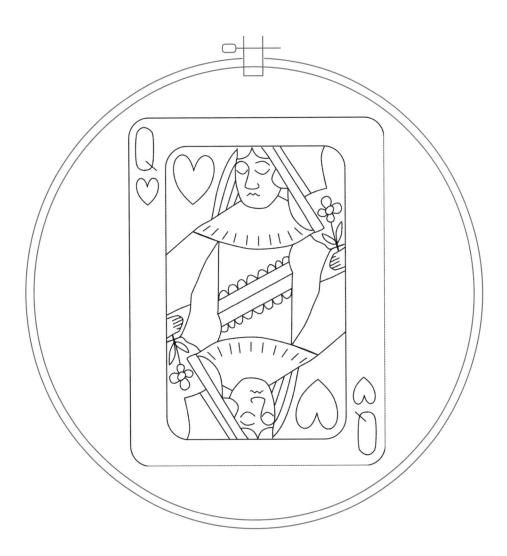

DIFFICULTY RATING

THREAD COLOUR REF

797

THREAD INSTRUCTIONS

*2 x strands
back stitch*

FEMINISM
MEANS
EQUALITY

It's really that simple.

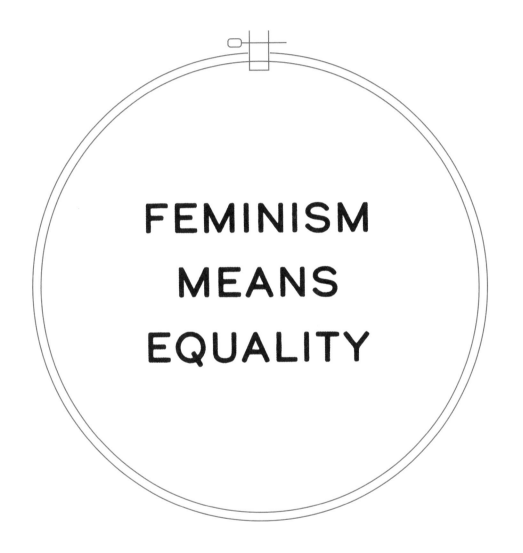

RESPECT MY EXISTENCE

DIFFICULTY RATING

THREAD COLOUR REF

796

THREAD INSTRUCTIONS

*2 x strands
back stitch*

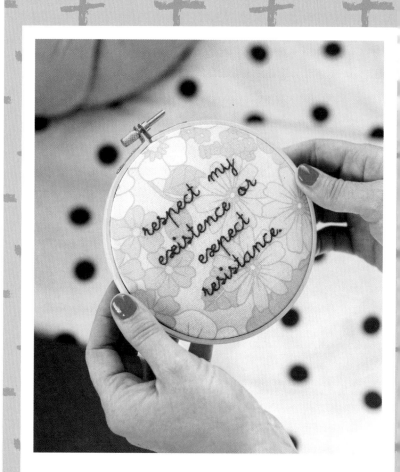

We're not going anywhere, so get used to it.

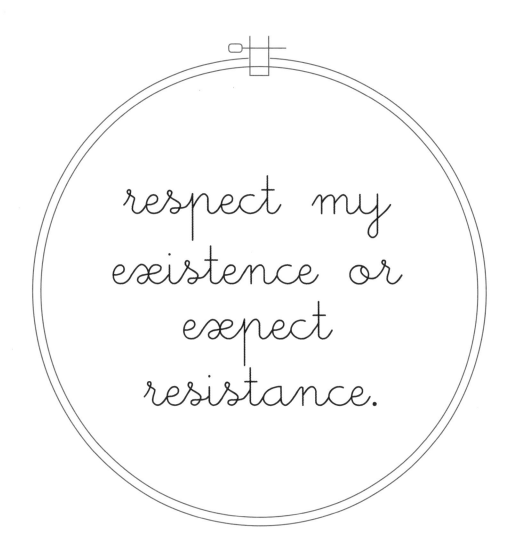

respect my existence or expect resistance.

A WOMAN'S PLACE

DIFFICULTY RATING

THREAD COLOUR REF
ECRU

THREAD INSTRUCTIONS
*2 x strands
back stitch*

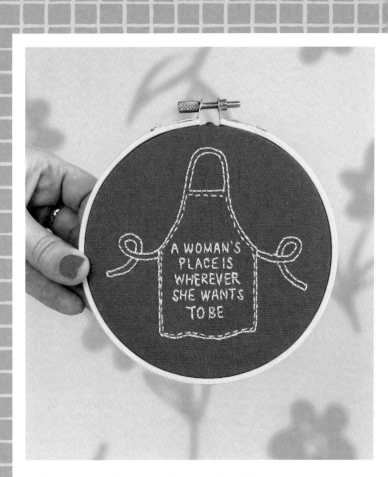

A WOMAN'S PLACE IS WHEREVER SHE WANTS TO BE

A woman's place is wherever decisions are being made. In the boardroom, in the law courts, in parliament, in the pizza place... wherever she chooses to be.

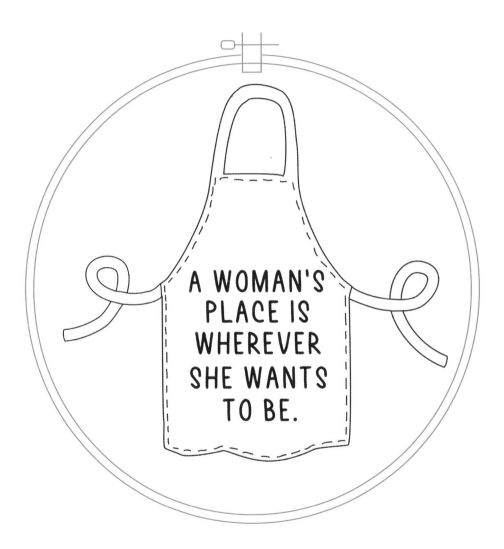

HERE'S TO STRONG WOMEN

DIFFICULTY RATING

THREAD COLOUR REF
Neon Pink

THREAD INSTRUCTIONS
*2 x strands
back stitch*

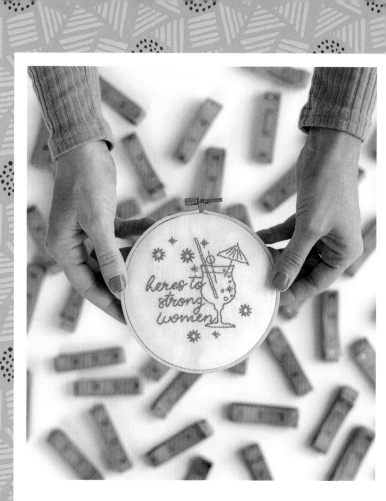

Raise a glass to them! Here's an embroidery for your strong, inspiring, cocktail-loving friends. May their glasses always be full and their dreams be fulfilled.

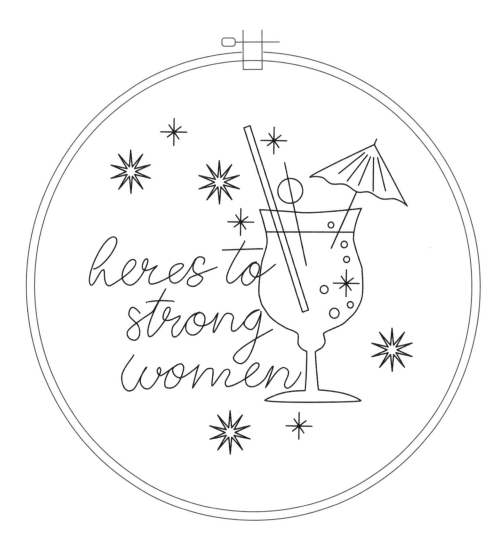

BE FEARLESS

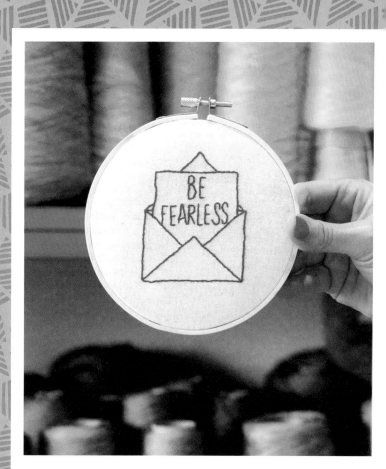

DIFFICULTY RATING

THREAD COLOUR REF
666

THREAD INSTRUCTIONS
*2 x strands
back stitch*

Be brave, take the risk. We promise it'll be worth it.

When in doubt, remind yourself of Emma Watson's mantra: 'If not now, when? If not me, who?'

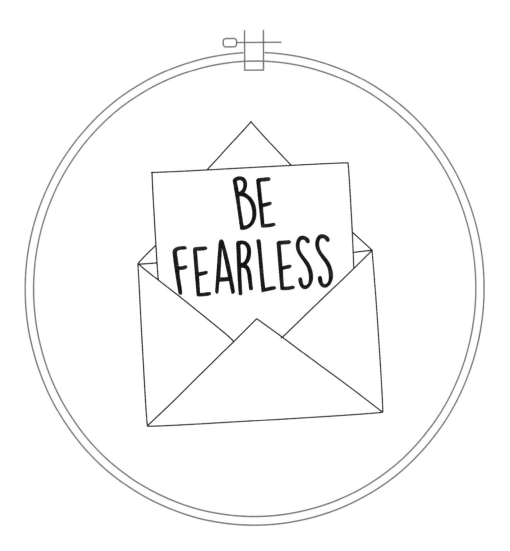

EMPOWERED WOMEN EMPOWER WOMEN

DIFFICULTY RATING

THREAD COLOUR REF

166

THREAD INSTRUCTIONS

*2 x strands
back stitch*

Be sure to surround yourself with powerful women.
They are the best!

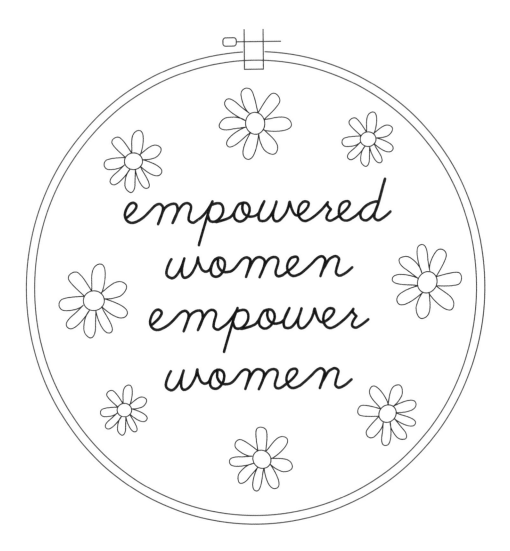

**DIFFICULTY
RATING**

**THREAD
COLOUR REF**

B5200

**THREAD
INSTRUCTIONS**

*2 x strands
back stitch*

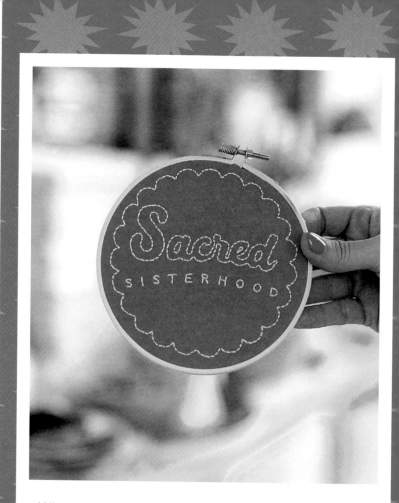

Where would we be without our sisterhood to support us, make us laugh and give us the strength to fight the good fight?

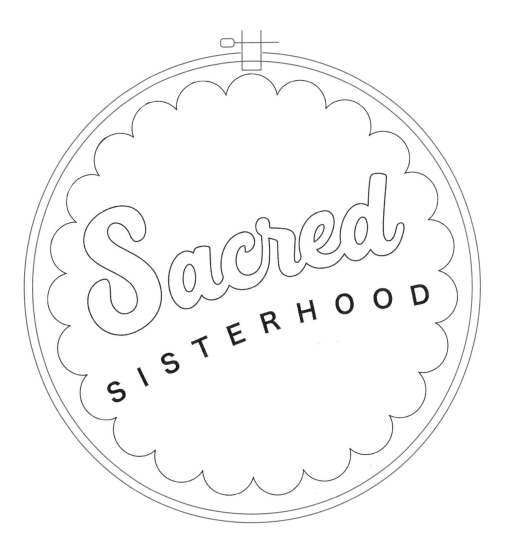

PROTEST THIS SHIT

DIFFICULTY RATING

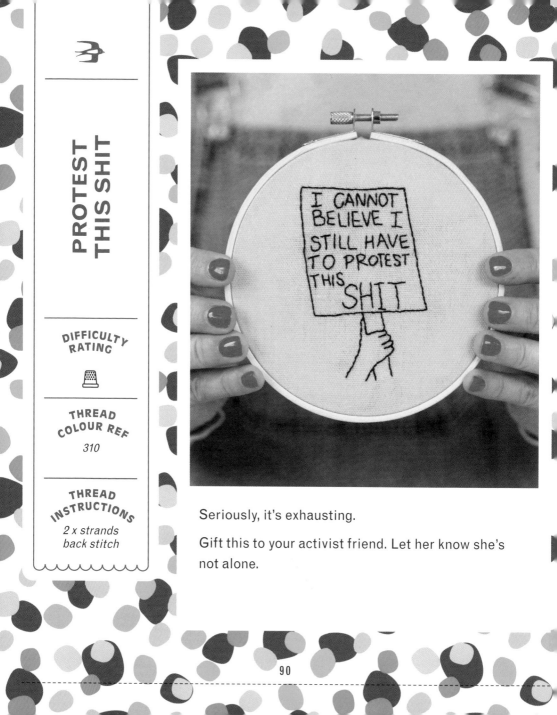

THREAD COLOUR REF

310

THREAD INSTRUCTIONS

*2 x strands
back stitch*

Seriously, it's exhausting.

Gift this to your activist friend. Let her know she's not alone.

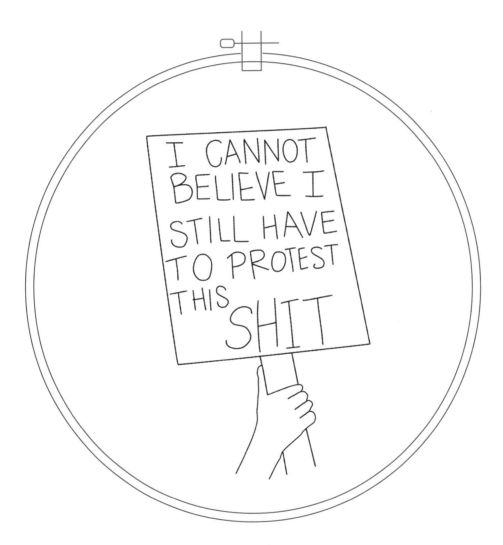

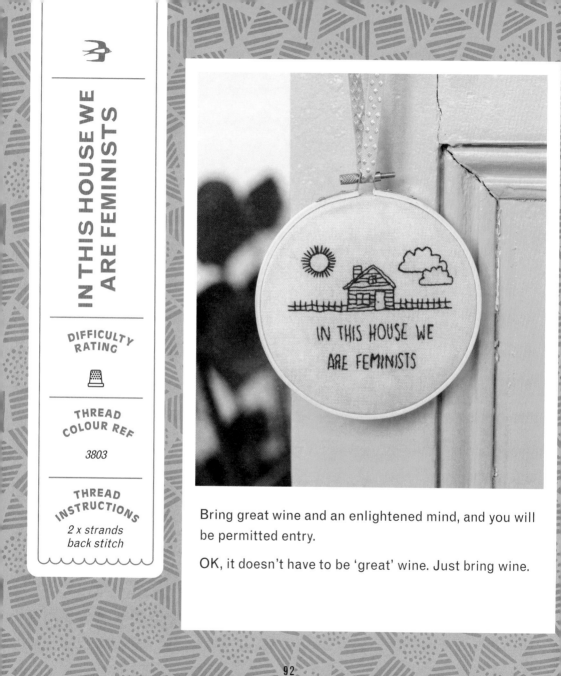

DIFFICULTY RATING

THREAD COLOUR REF

3803

THREAD INSTRUCTIONS

2 x strands
back stitch

Bring great wine and an enlightened mind, and you will be permitted entry.

OK, it doesn't have to be 'great' wine. Just bring wine.

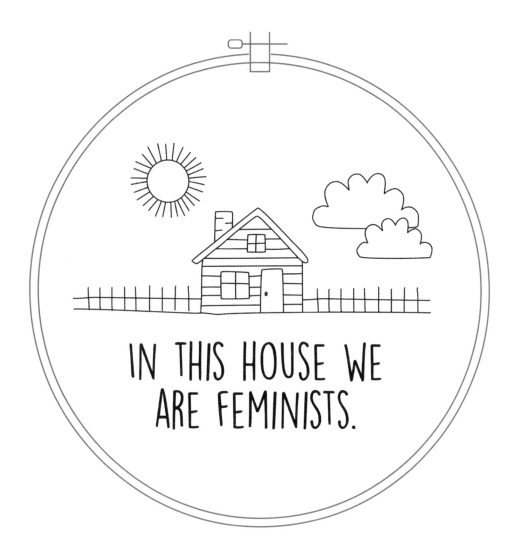

DIFFICULTY RATING

THREAD COLOUR REF
ECRU

THREAD INSTRUCTIONS
2 x strands
back stitch

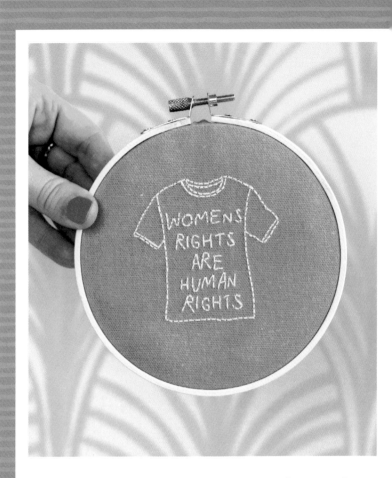

Say it with us! Then shout it from the rooftops so that misogynistic neighbour of yours gets the message loud and clear.

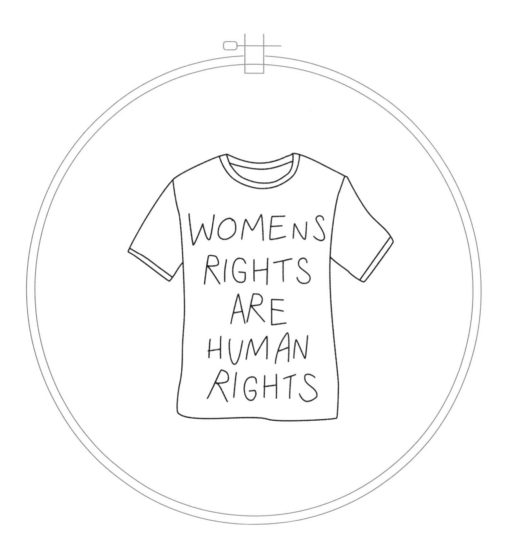

ENOUGH

DIFFICULTY RATING

THREAD COLOUR REF

310

THREAD INSTRUCTIONS

*2 x strands
back stitch*

'I am enough.' Repeat after us, until you believe it.

Then five times more for good measure.
Then another five times louder for fun.

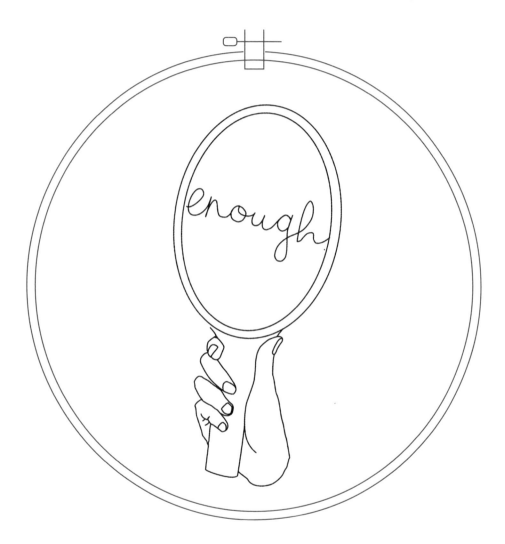

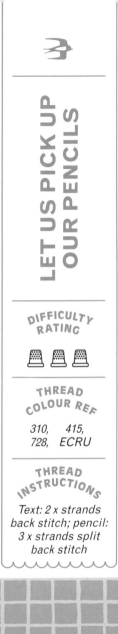

LET US PICK UP OUR PENCILS

DIFFICULTY RATING

THREAD COLOUR REF

310, 415,
728, ECRU

THREAD INSTRUCTIONS

Text: 2 x strands back stitch; pencil: 3 x strands split back stitch

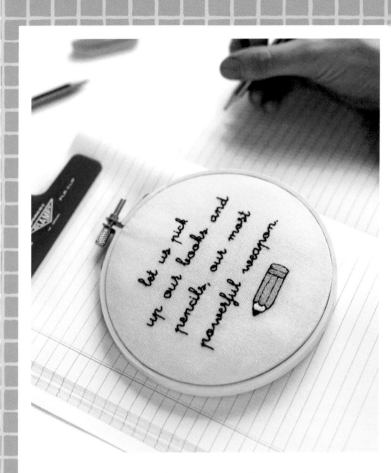

Dig out that notebook and do not disobey Malala. She will know if you do.

Start planning, plotting, doodling, whatever you want to – just start creating!

let us pick
up our books and
pencils, our most
powerful weapon.

STRONGER TOGETHER

DIFFICULTY RATING

THREAD COLOUR REF

B5200

THREAD INSTRUCTIONS

*2 x strands
back stitch*

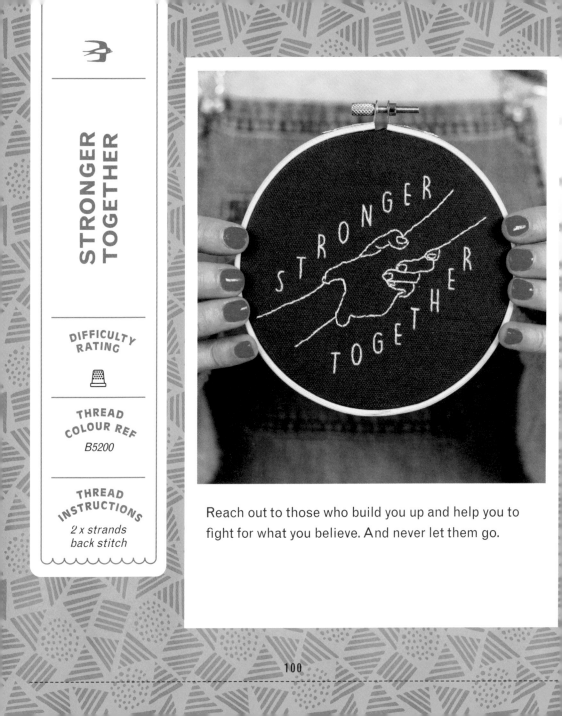

Reach out to those who build you up and help you to fight for what you believe. And never let them go.

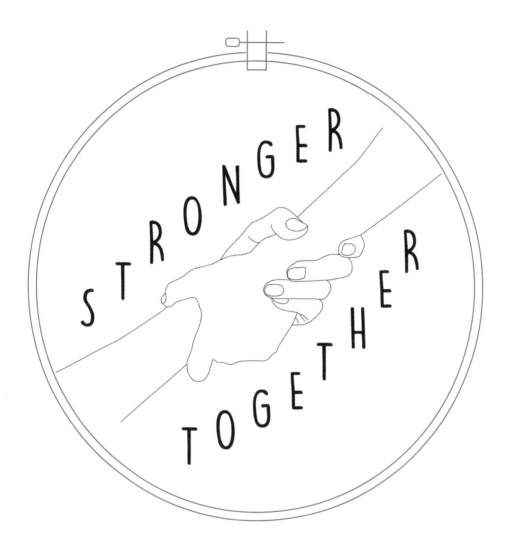

DIFFICULTY RATING

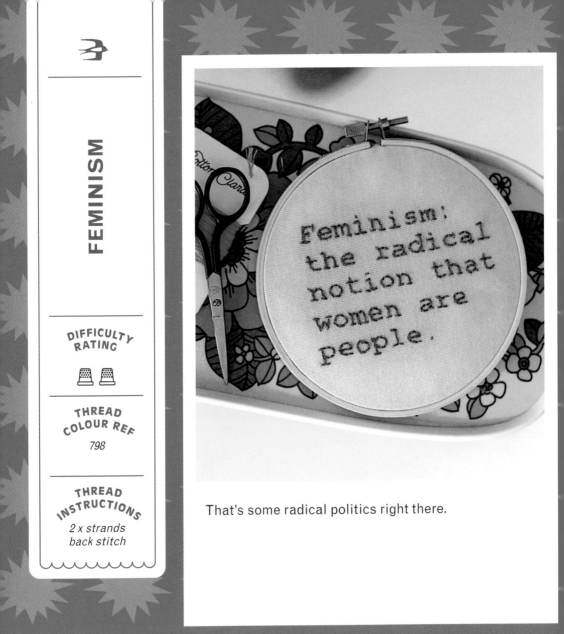

THREAD COLOUR REF

798

THREAD INSTRUCTIONS

*2 x strands
back stitch*

That's some radical politics right there.

Feminism:
the radical
notion that
women are
people.

YOU ARE WONDERFUL

DIFFICULTY RATING

THREAD COLOUR REF

909

THREAD INSTRUCTIONS

*2 x strands
back stitch*

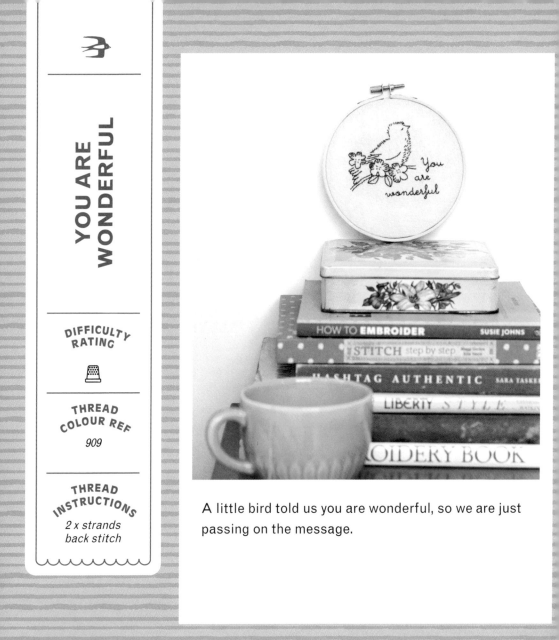

A little bird told us you are wonderful, so we are just passing on the message.

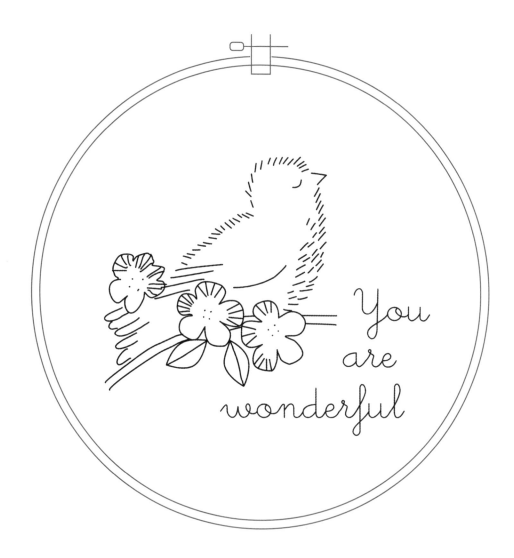

**DIFFICULTY
RATING**

**THREAD
COLOUR REF**

976

**THREAD
INSTRUCTIONS**

*2 x strands
back stitch*

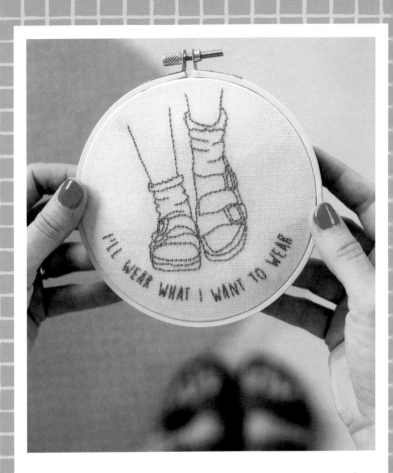

Socks and sandals? Yes please. Pyjamas and boots?
Why not?! Wear whatever makes you feel GREAT.

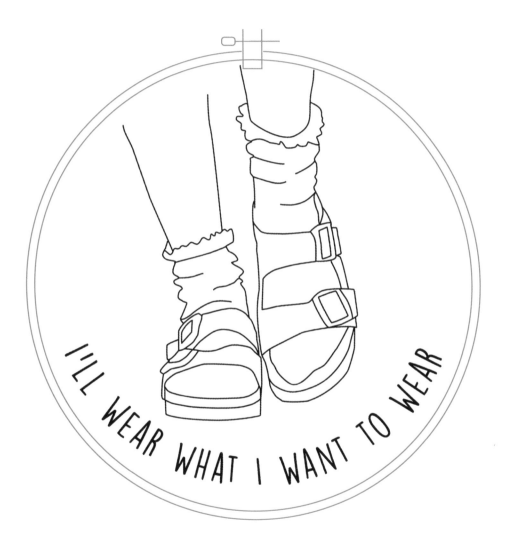

I'LL WEAR WHAT I WANT TO WEAR

SHE SHINES LIKE A DIAMOND

DIFFICULTY RATING

THREAD COLOUR REF

B5200

THREAD INSTRUCTIONS

*2 x strands
back stitch*

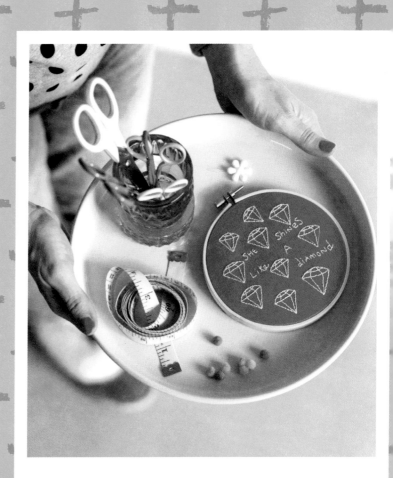

Strive to be the brightest in every room.
Be the guiding light for others.

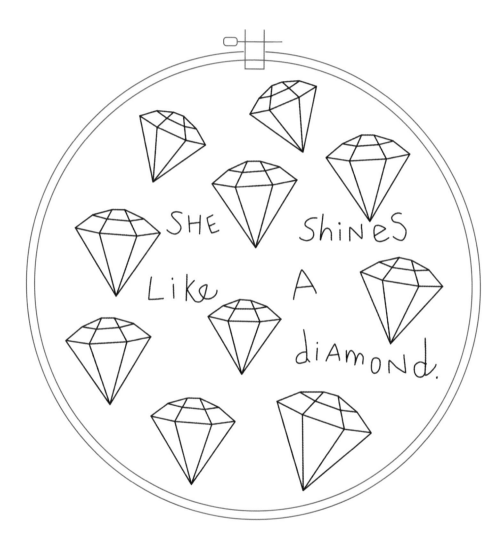

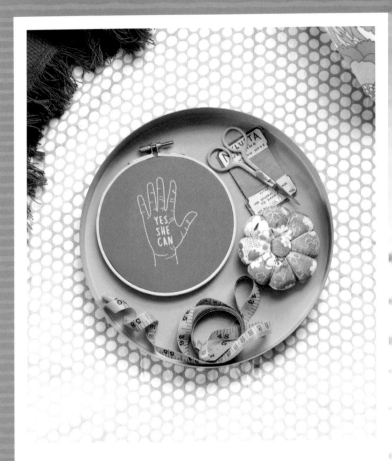

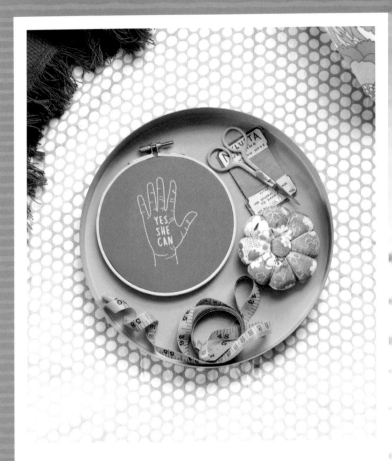

YES SHE CAN

DIFFICULTY RATING

THREAD COLOUR REF
ECRU

THREAD INSTRUCTIONS
2 x strands
back stitch

And don't let anybody tell her otherwise.

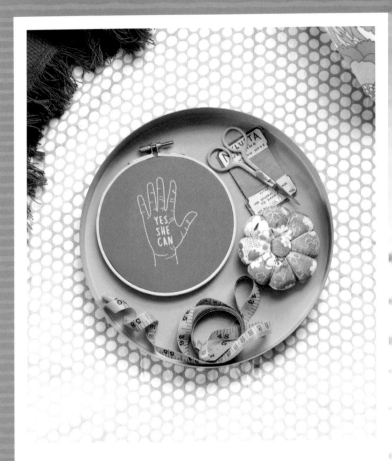

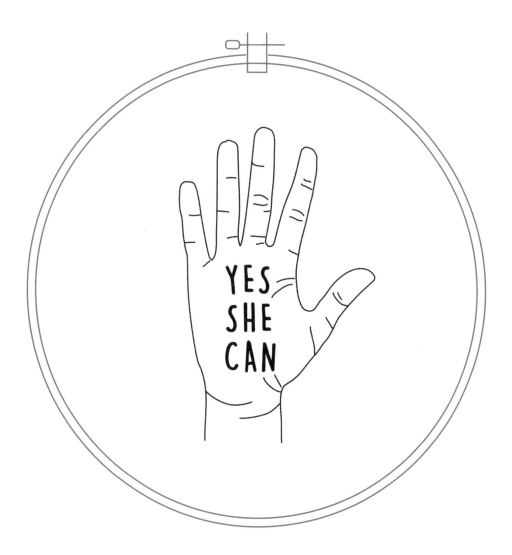

EQUAL WORK EQUAL PAY

DIFFICULTY RATING

THREAD COLOUR REF

912

THREAD INSTRUCTIONS

2 x strands back stitch

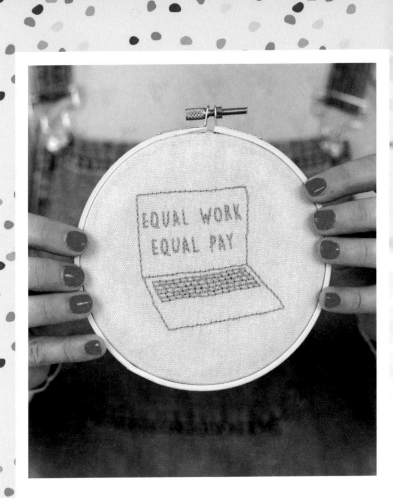

Kindly pay us what we're owed. Then add another third. And throw in some extra holiday. Thanks.

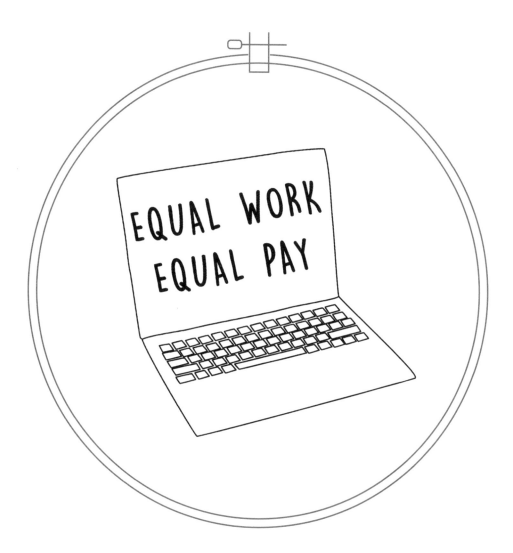

PLEASE BECOME THE CEO

DIFFICULTY RATING

THREAD COLOUR REF

826

THREAD INSTRUCTIONS

2 x strands back stitch

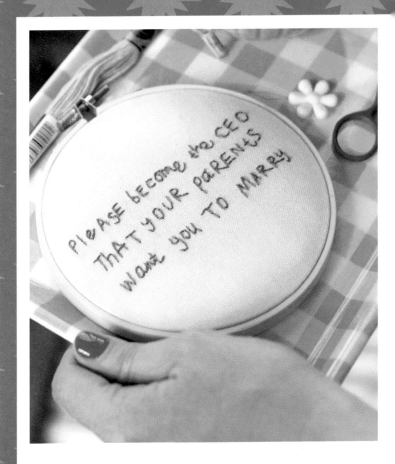

Please do this. For women everywhere. Then throw a massive party for yourself.

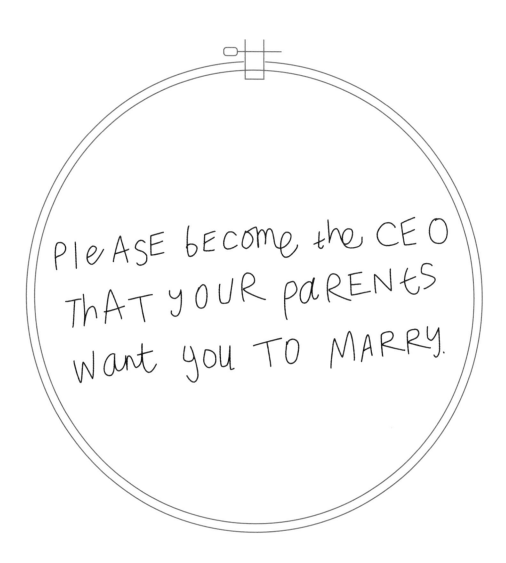

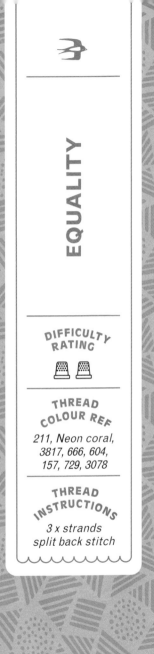

DIFFICULTY
RATING

THREAD
COLOUR REF

*211, Neon coral,
3817, 666, 604,
157, 729, 3078*

THREAD
INSTRUCTIONS

*3 x strands
split back stitch*

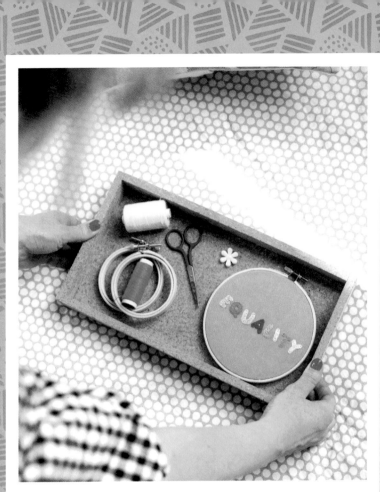

The time is now. We've all waited long enough.

A WOMAN WITHOUT A MAN

DIFFICULTY RATING

THREAD COLOUR REF

900

THREAD INSTRUCTIONS

*2 x strands
back stitch*

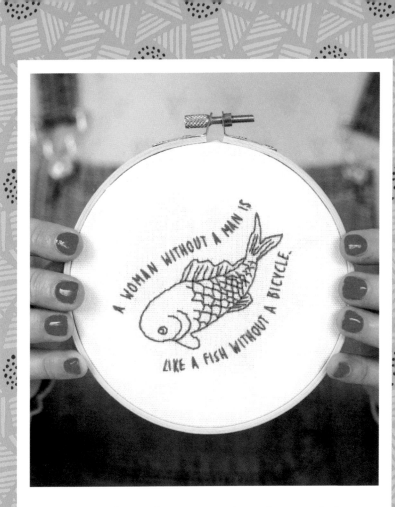

Thank you, Gloria Steinem, not least for popularising this fabulous quote.

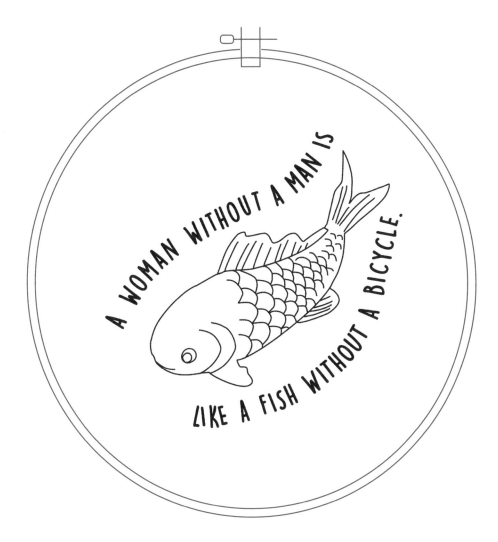

BE BOLD

DIFFICULTY
RATING

THREAD
COLOUR REF
ECRU

THREAD
INSTRUCTIONS

*Be bold text: 3 x
strands back stitch;
everything else: 2 x
strands back stitch*

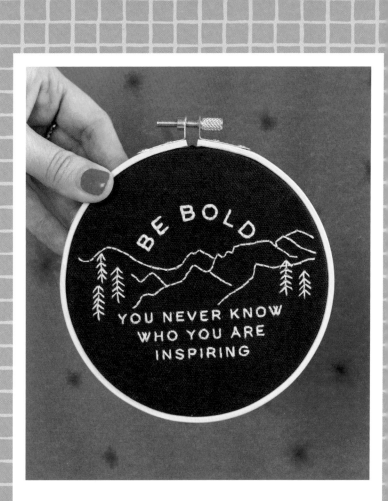

Because we need more role models. You know HE is going to be bold so why not you?

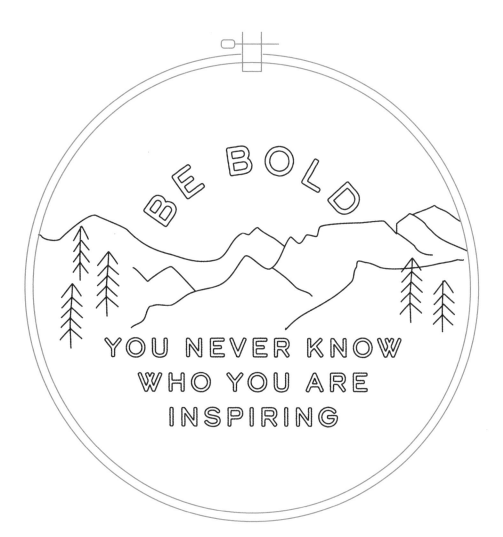

DIFFICULTY
RATING

THREAD
COLOUR REF
956

THREAD
INSTRUCTIONS
*2 x strands
back stitch*

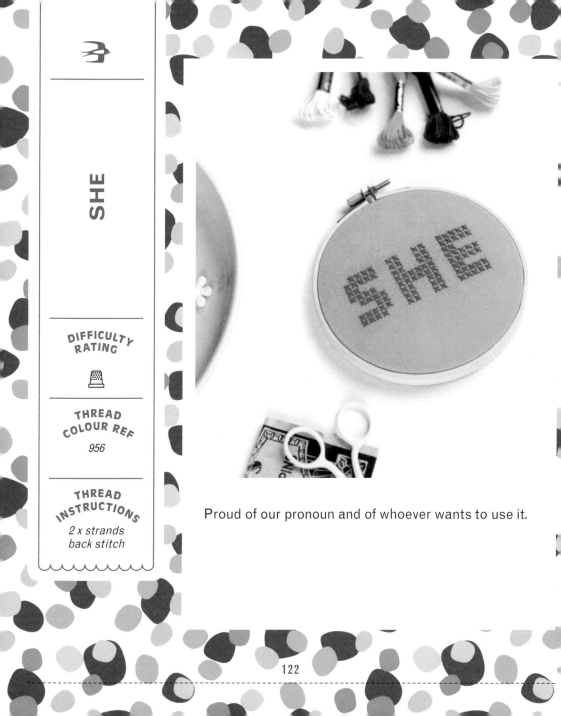

Proud of our pronoun and of whoever wants to use it.

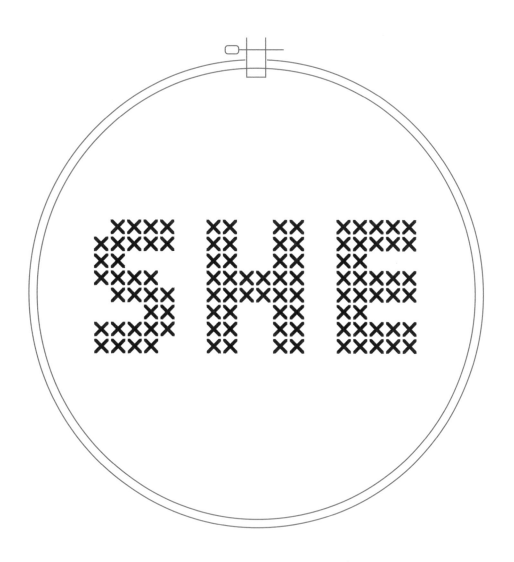

NOT YOUR RIVAL

DIFFICULTY RATING

THREAD COLOUR REF
909

THREAD INSTRUCTIONS
2 x strands
back stitch

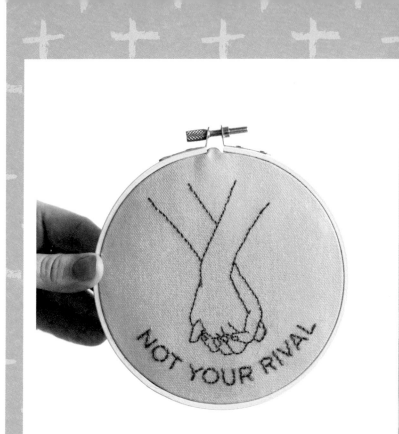

Community over competition. Be the woman who fixes another's crown, without telling the world it was crooked.

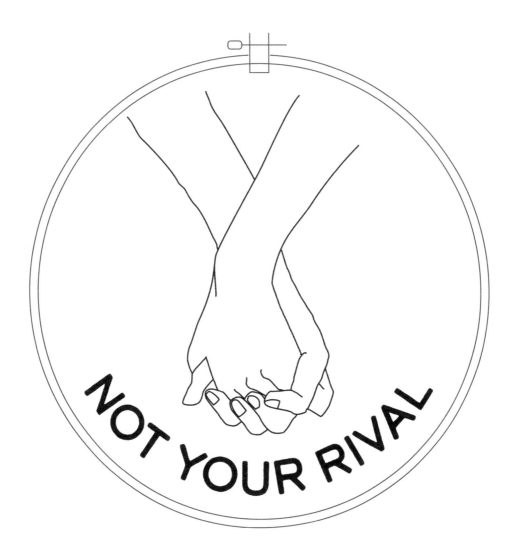

TEACH GIRLS TO BE SOMEBODIES

DIFFICULTY RATING

THREAD COLOUR REF

780

THREAD INSTRUCTIONS

2 x strands back stitch

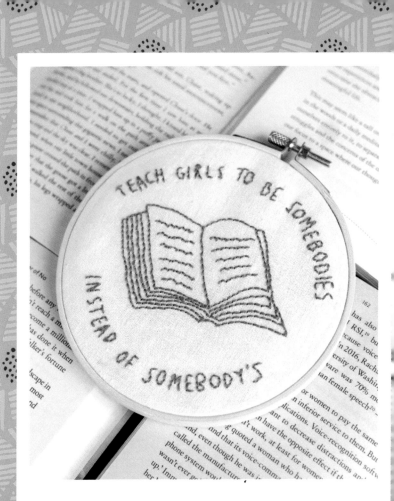

Knowing your own worth aside from being a partner is counter cultural and there are lessons to be learnt from the pages of some of the great feminist writers.

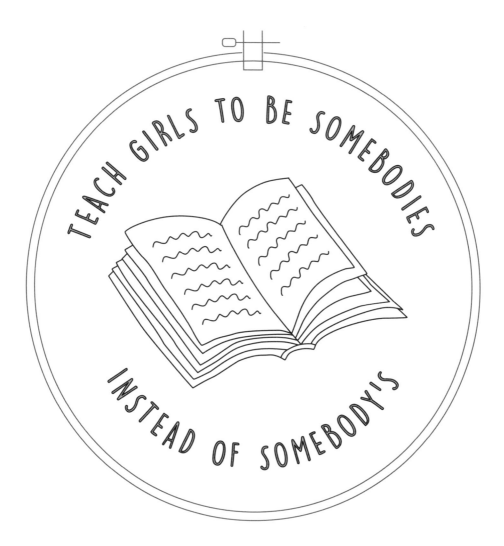

ACKNOWLEDGEMENTS

I want to thank my husband for supporting me
and every crazy idea I bring to him, all of my
strong female friends and family who inspire me
to follow my dreams and the editorial team at
HarperCollins for believing I could write a book!
To my wonderful photographer Holly and to the
army of stitchers who worked so hard to get all
the hoops ready for this book – thank you!

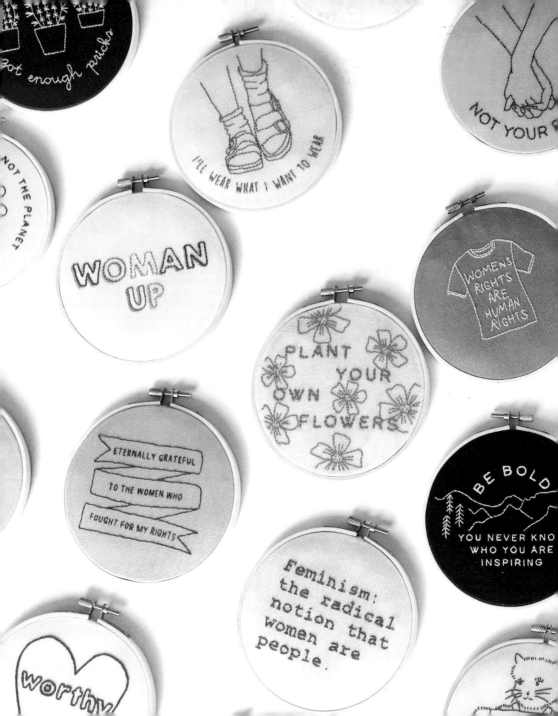